WALWORTH

THROUGH TIME

A SECOND SELECTION

Mark Baxter *&* Darren Lock

AMBERLEY PUBLISHING

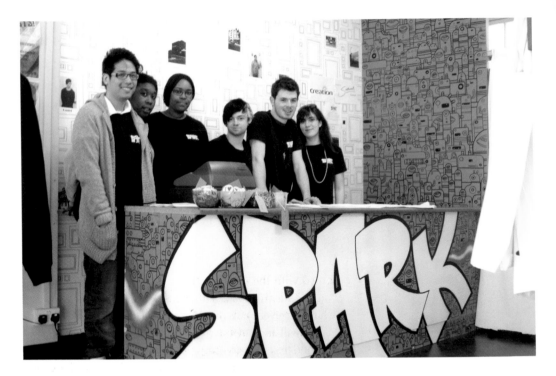

SPARK Pop Up Shop, 57–59 East Street
In March 2012, the Creation Trust in association with Southwark Council set up this project on the street market of East Street to give unemployed people aged between sixteen and twenty-four an insight into the retail sector and on the job training. The shop sold locally made products, such as 'I Love Walworth' t-shirts, hoodies, badges, bags and cups. They also sourced local arts and crafts, which were available to buy in the shop. The enterprise gained television and radio coverage and gave out a very positive message about the young people of SE17. Among those who worked at and ran SPARK were Roanna, Cameron, Coby, Navika, Daniel and Shakira.

First published 2012

Amberley Publishing
The Hill, Stroud
Gloucestershire, GL5 4EP

www.amberley-books.com

Copyright © Mark Baxter & Darren Lock, 2012

The right of Mark Baxter & Darren Lock to be identified as the Authors of this work has been asserted in accordance with the Copyrights, Designs and Patents Act 1988.

ISBN 978 1 4456 0709 2

British Library Cataloguing in Publication Data. A catalogue record for this book is available from the British Library.

Typeset in 9.5pt on 12pt Celeste.
Typesetting by Amberley Publishing.
Printed in the UK.

Introduction

We were delighted with the response that our 2010 book for Amberley *Walworth Through Time*, received, both locally and, going by the letters and emails we have received since publication, nationally and even around the world. The goodwill and obvious affection for that part of London was both lovely to see and in some ways surprising, even to us. To the untrained eye, it can look a little tatty in places, but dig a little deeper and you will find warmth among a vibrant community. Someone described the book as a love letter to the area of Walworth and that sums it up exactly, so we were delighted to be invited to do a follow-up book for 2012.

In the first one we concentrated solely on the postcode of SE17, being very strict not to stray too far from home. We felt it was important to point out all the things and places that meant so much to us. For this book, though, we have loosened the boundaries a little and have written about and photographed places of interest in the immediate surrounding area. So we have highlighted not only parts of Walworth, but also the Elephant and Castle, the Old Kent Road, Camberwell and Kennington, as well as revealing a few more hidden gems of SE17.

We have also included biographies on local characters that many will remember, some of whom went on to gain global recognition. A lot of the entries we have included are places of entertainment, alongside places of worship. We look at sporting arenas, at retail units of long standing and further education establishments – all of which local people have used as part of their everyday life.

The fascinating thing for us in writing, photographing and researching this book has been the incredible stories that the work has uncovered. For instance, did you know of the connection of footballer David Beckham with the tragic loss of members of a local Walworth Boy Scout Troop in 1912? Or that future US presidential candidate and brother of the legendary JFK, Robert 'Bobby' Kennedy, made his very first speech in SE5 aged just thirteen!

We also love a bit of the quirky and obscure, so in the following pages you will find statues in the strangest of locations and monuments that have been erected, then moved, and then re-located back to where they originally started. We've even got 'stink' pipes that are over 30 foot tall that no one ever notices!

So, once again, please settle back and let us take you on a journey through the 'deep south' of London, where we will point out to you plenty of places of interest that will hopefully educate and amuse... to Walworth and beyond!

Darren Lock and Mark Baxter
Spring 2012

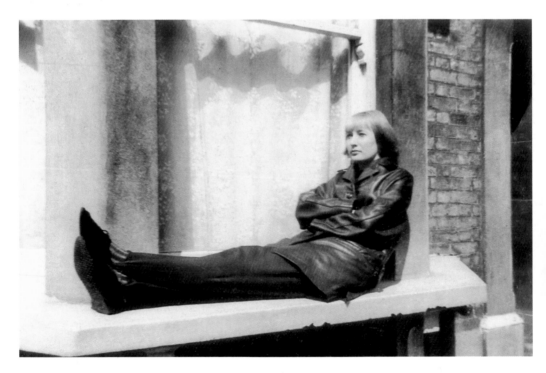

Seen here in the 'Swinging 1960s', Maggie Webb née Layle relaxes on a window ledge at 9 Nursery Row.

George Barnes, East Lane Market *c.* **1971**
'If you want to live forever, you must drink
my sarsaparilla! That was the familiar
cry of former butcher George Barnes, a
larger-than-life character who is fondly
remembered for selling a variety of hot
and cold drinks from a stall in East Street
market as can be seen from the photograph
of him below. George was a local man,
living just a few streets from his pitch. He
would sell you a piping hot glass in the
winter and a cooling drink in the summer
months. He was mainly known for selling
his own brand of sarsaparilla, which he
and his wife Flo bottled up locally in a
nearby lock-up. It has long been believed
that a drink made from the root of the
sarsaparilla plant from the Caribbean is
good for your health, a good tonic if you
will. The herbalist Baldwins at 171/173
Walworth Road still sell their own version
of the drink by the bottle, or you can buy a
half or full pint at the shop. As old George
would have said, ''ere y'are mum, it's good
for yer blood!'

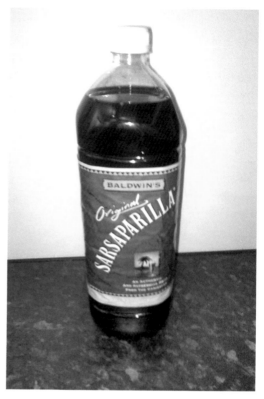

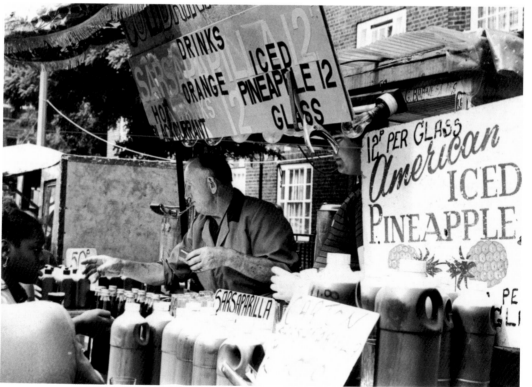

Roffos, c. 1970s

It is said the finest ice cream in South London could be found on the corner of East Street at 275 Walworth Road, where the Roffo family had an outlet, trading as Ernesto Roffo & Sons. They had a secret recipe, which they never revealed. They also had a classic Italia café in East Street. They were a fixture in the area from 1936 until 2004 and were well loved. Among the names that many will remember will be Felice, Frank and Rachel. Many Italian families had settled in Southwark, but upon the outbreak of Second World War many were interned or deported. Some of those were on the ship the SS *Andora Star*, which was sunk by a German U-boat in July 1940 resulting in many deaths. The corner unit that the Roffos worked from is now the Green Communications mobile phone outlet.

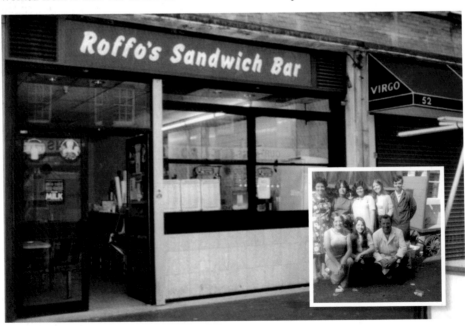

Johnny Wallingon MBE, *c.* **1980**
Johnny Wallington's grandfather was given one of the first official licences to trade in East Lane Market, as it was known then in 1927. The market had officially begun in 1880 but it was a free-for-all in getting the best pitches until it became more organised by the GLC *c.* 1923. Johnny was born on the Walworth Road, near to what is now Cuming Museum. He gained a scholarship to Wilsons Grammar School in Camberwell and after working in the print for over a year, he followed his father into the market aged seventeen. He met his wife when she worked on the market too. Their son Tony then began working on the stall, known for selling kitchen and household goods, thus meaning that four generations of the family have worked there. Johnny was the secretary of the East Street Traders Association for many years and he was awarded an MBE for his services to that and his other voluntary work. After sixty years in the market, Johnny retired in 2008, though he retains an active interest in keeping it alive.

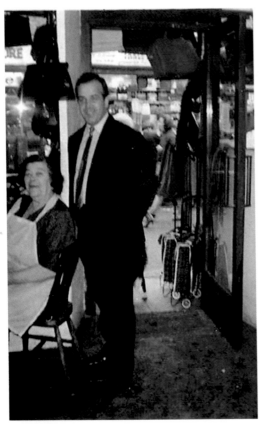

W. E. Charlesworth, 46 East Street,
c. 1970s
Its shop sign proudly states 'Charlesworth of East St'. This longstanding local business started tanning and dressing leather in 1910. It is well known for the variety of luggage, bags and shoes it sells. Sidney Charlesworth, the current owner, was born in the shop. It suffered bomb damage during the Second World War and was eventually rebuilt in 1957. Another familiar site is the Charlesworth market stall, which stands outside the shop.

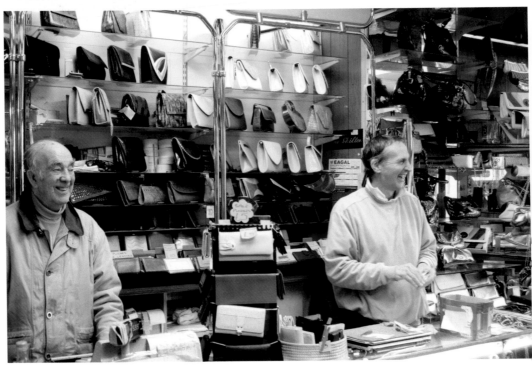

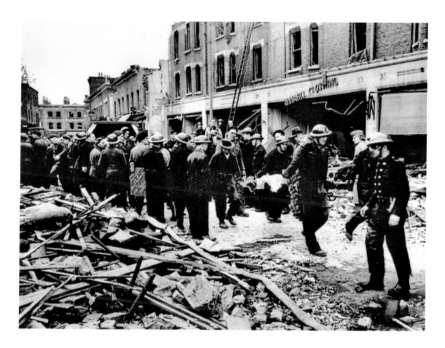

Bomb Attacks on SE17, East Street, c. 1940s

Over the summer of 1944 the area of SE17 was targeted in bombing raids. As can be seen from the photograph of East Street, above, the damage was extensive, as was the loss of life. A total of forty-three people died over the three months of June, July and August, with many more injured. The V1 flying bomb in particular wreaked havoc, with parts of Sutherland Square, Manor Place, Penrose Street, Dawes Street, and Westmoreland Road also attacked, resulting in hundreds of damaged and destroyed buildings. This, in part, explains the massive 'patchwork' effect of social housing constructed in the area since, with many differing styles being built and sadly proving to be, in the long-run, unsuccessful. The piano at St Peters church still carries its battle scars from the direct hit the church suffered in 1940.

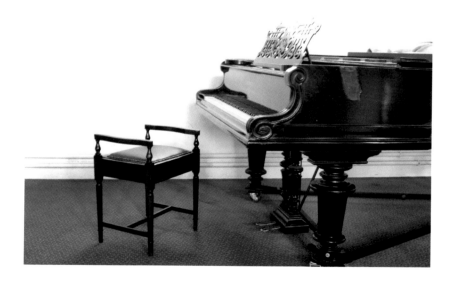

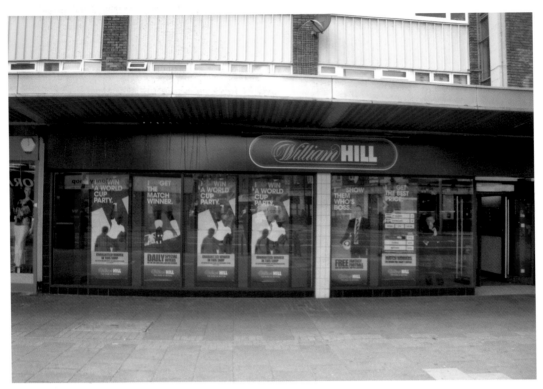

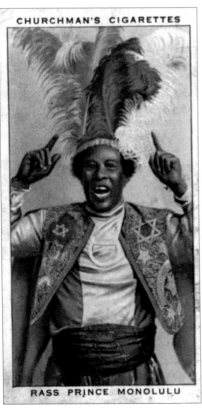

CHURCHMAN'S CIGARETTES

RASS PRINCE MONOLULU

Prince Monolulu – East Street Market SE17, c. 1953

'I Gotta Horse! I Gotta Horse!' – That cry belonged to a fascinating character known as Prince Monolulu, once a familiar figure on the streets and racecourses of the UK. Born Peter Carl McKay on the island of St Croix in the West Indies in 1881, Monolulu arrived in the UK in 1902 and was soon treading the boards in West End Musicals. He travelled to Europe working as a lion tamer and fortune teller. In West Germany at the outbreak of the First World War, he was interned for the remainder of the conflict. Returning to England, he began to work as a racing tipster. Flamboyantly dressed, with colourful jackets and feathers in his hair, for a small fee he would sell a punter a sure fire winner, hence his famous saying. He won £8,000 backing the horse Spion Kop in 1920, an extraordinary sum back then. Such was his fame that he became the first black person to appear on television in 1936, on the very first day the BBC began broadcasting. Later he could be found selling his tips in East Street market. He lost most of his money backing a horse called Bally Moss in 1958, but worked his trade until his death in 1965 at the age of eighty-four. His 'service' has been replaced today by the likes of William Hill, one of seven betting shops on the Walworth Road.

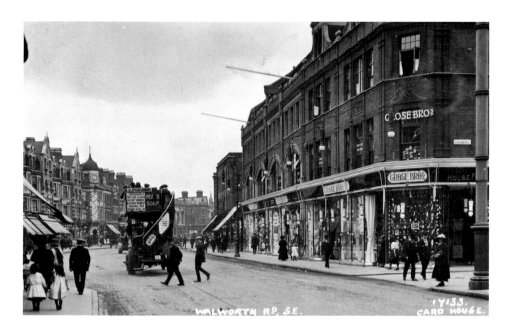

Stink Pipes, Walworth Road, 1900s

They stand very tall, made of iron, painted green and rise out of the ground like giant weeds and are seen in many parts of London, though few people take much notice of them. We're talking stink pipes. Over the years many have thought them to be disused street lamps, but they are in fact part of the Victorian sewer system. Built around the 1860s, they are hollow pipes that allow unpleasant gases to escape into the atmosphere high above the roofs of the surrounding streets. The one seen to the right of this photograph from early 1900 is still in position today. Others can be seen locally near Addington Square and Albany Road; all in all, an odd but rather lovely piece of old London.

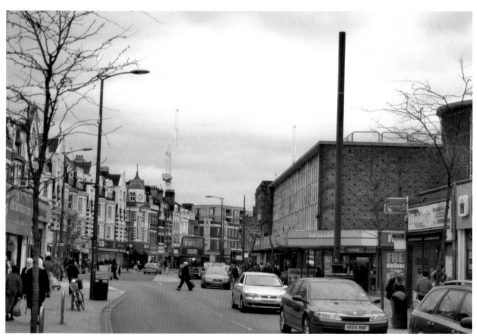

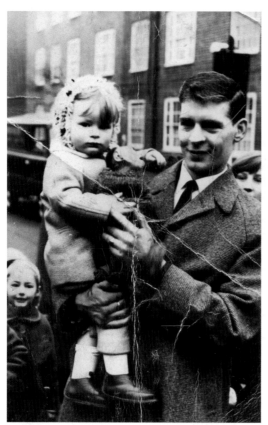

**Street Entertainers and Local Performers,
c. 1964 and 2011**
A familiar sight in East Street market
from the 1950s to the early 1980s was a
photographer who held a tiny monkey.
For a small fee he would hand over the
monkey to a toddler being held in the arms
of their father, like the young lady left, and
the owner would then take a photograph.
Someone else regularly seen strutting
his stuff in Walworth is singer, DJ, artist,
trained clown and all round fashionista,
Mr Natty Bo. Growing up in South London,
Nat has an obvious fondness for SE17,
though he can be seen performing with his
bands, The Top Cats and SkaCubano, on
the live circuit all over the world.

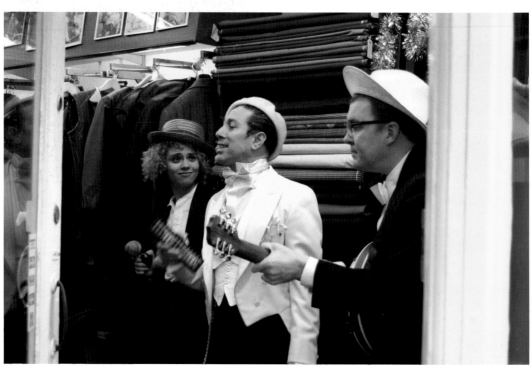

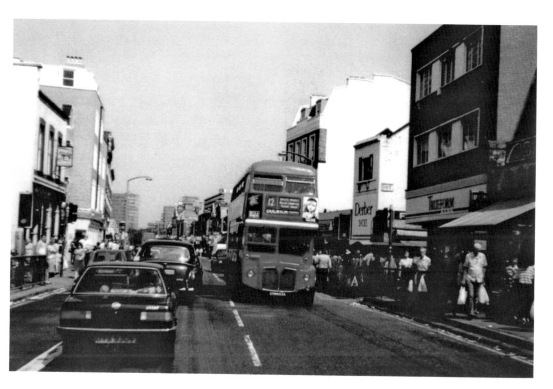

The Number 12 Bus, 1980s

This route, the most popular for those travelling to the West End, goes through Camberwell, Walworth and the Elelphant and Castle. The no. 12 travels over Westminster Bridge, down Whitehall, through Piccadilly, before terminating at Oxford Circus. It ran on to Notting Hill Gate until 2005. The bus begins its journey at Dulwich Library. We can thank one Thomas Tilling for this route. He started his company with one horse and cart operating out of Walworth in 1846. Upon his death, his sons carried on the business, gradually introducing motorbuses, including the thrity-four seat double-decker in 1904. In 1909, Tilling's joined forces with the London General Omnibus Company and route 12 was assigned to them, running from Peckham to Oxford Circus. It is believed to be the oldest operating bus route in London. For those travelling on the bus in the 1970s and '80s, the conductor Anthony Severin will be fondly remembered. Originally from Trinidad, he was immaculately dressed and so courteous and helpful that he was awarded a people's choice MBE in 1994. He arrived at Buckingham Palace on his double-decker to collect his award. The people of Walworth are currently campaigning to have a street named after him.

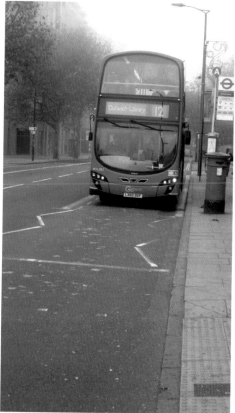

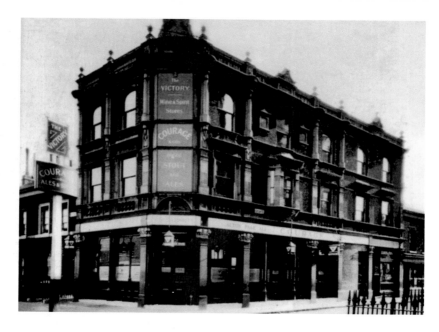

The Victory Pub, 32 Barlow Street, *c.* 1940s

One of a long line of local establishments named in commemoration of the Battle of Trafalgar of 21 October 1805. The sea battle raged between the British Navy and the French and Spanish. The ship HMS *Victory*, under the command of Admiral Lord Nelson, was part of the Royal Naval fleet that sunk twenty-two Franco-Spanish ships, without a single loss on the British side. The victory came at a cost however, with Nelson mortally wounded. He became a national hero, honoured most markedly with Nelson's Column in Trafalgar Square in Central London, but also more locally in SE17, with The Lord Nelson pub, the Nelson and Victory schools, Cadiz Street and Trafalgar Street. The exterior of the Victory pub was used in a Courage Best television advert from 1981, featuring the popular Chas and Dave song 'Rabbit'. Sadly this one time Courage Alton brewery, with its ornate ceiling pillars, closed in 2011 and is now apartments.

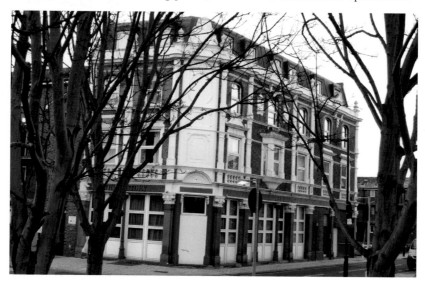

Charlie Chaplin, East Street SE17, 1920s and 1950s

A huge Hollywood star in the early twentieth century, he became one of the world's most recognised people. But his start in life was anything but glamorous. Charles Spencer Churchill was born in April 1889 above a shop in East Street, SE17. Both his parents were music hall performers who were married at St John's Church in Larcom Street. However, they had separated by the time young Charlie was three. At this time, he and his half-brother Sydney were living with their mother in Barlow Street, Walworth. With his father, Charles Senior, an alcoholic, and his mother Hannah committed to an asylum, the young Chaplin ended up in the Newington workhouse by 1896. His grim existence in this institution was later to be the inspiration for his character of the lonely tramp. Young Charlie was a natural performer and he joined a group of dancers called The Eight Lancashire Lads, gaining acclaim for his tap-dancing skills. He toured the United States as a member of The Fred Karno Troupe from 1910 to 1912. Striking up a friendship with Stan Laurel, he decided to remain in the US, where he joined the Keystone Film Co. overseen by Mack Sennet.

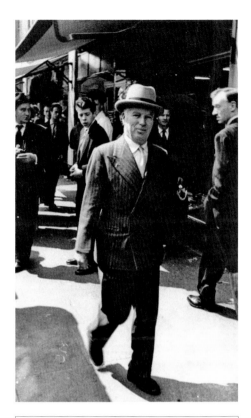

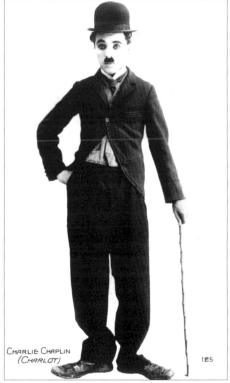

CHARLIE CHAPLIN
(CHARLOT) 125

15

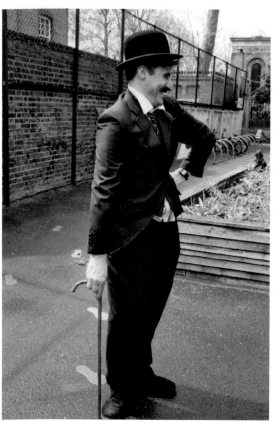

Charlie Chaplin, *c.* 1966/2012

Chaplin's films, starring the little tramp in his trade mark bowler hat, small moustache and walking cane were very soon big box office hits, and he became a major star. In 1919 he co-founded United Artists. The classic silent films, including *The Kid, The Gold Rush, City Lights* and *Modern Times,* continued. His first 'talkie' was *The Great Dictator* in 1940, which was a swipe at Hitler and the Nazis. Alongside his films, Chaplin was also a celebrated song writer. His song 'Smile', was famously covered by Nat King Cole in the mid 1950s, and Petula Clark had a number one hit with his composition 'This Is My Song' in 1967. Chaplin occasionally re-visited the area of his birth, but finally settled in Switzerland. He was knighted in 1975. He died on Christmas Day 1977, survived by wife Oona and their eight children. Bizarrely, his corpse was stolen and the robbers tried to extort money from the family. The plot failed and he was re-buried eleven weeks later. Local school caretaker and Chaplin aficionado Jacko McInroy is seen as his hero, left.

George the Barber's, 288 Walworth Road, 1980s

George arrived from Cyprus and set up a barbershop in Westmoreland Road, with his son Michael and Daughter Androulla, in the 1970s. He then moved to 288 Walworth Road, formerly known as Ben's, with his daughter continuing to run a women's salon at the old address. George's is very much the traditional barbers, complete with faded barbershop red, white and blue pole out front. Over the years, there have been some famous customers at the shop. One such customer is former WBC, WBA and IBF welterweight world boxing champ Lloyd Honeyghan, who grew up locally. Former Prime Minister Tony Blair visited the shop when it was convenient to the old Labour Party Headquarters, which were situated at 144–152 Walworth Road before moving to the Millbank Tower in 1997.

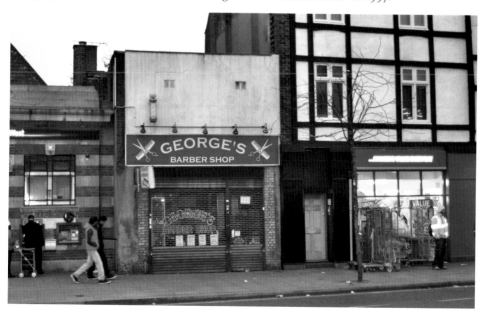

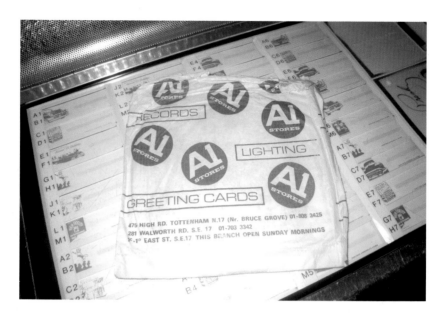

The A1 Stores, 281 Walworth Road, *c.* 2006

This much loved shop opened in 1912 and was a family run business. Generations of music lovers bought their singles and albums here over the years. As well as the main shop, there was a smaller unit in East Street market and another shop on Tottenham High Road. The small shop sign of 'Alsed and Dun' is fondly remembered. A1 also ran a small independent record label which released songs by the likes of Kenny Lynch and Jimmy Tarbuck, Jimmy Roselli and Rose Marie as well as DJ Steve Walsh whose song 'I Found Lovin' was very popular locally. Acts who over the years have appeared at in-store promotions here or in N17 include Scott Walker, The Spencer Davis Group, Perry Como and Marc Bolan. The shop also sold household lighting and greetings cards. The music arm of the business closed in 1999, with the shop then closing permanently in 2008. Since then it has been mainly empty apart from being a short-lived 'Ms London' clothes store.

Canon Horsley and Father Andrew Moughtin-Mumby, *c.* **1900 and 2012**
Father John William Horsley arrived at St Peter's church as its seventh rector in January 1894. He was an imposing figure, standing 6 feet tall and, as can be seen from the photograph right, he had a very distinctive appearance. He turned his own rectory garden into a small zoo for local children. It held small monkeys, and the land is still called Monkey Park to this day. He also set up a soup kitchen in the crypt. In 1904 he became the Canon of Southwark and held the position of Mayor of Southwark for a year in 1910. Father Andrew was born in 1978 in Montego Bay, Jamaica, and he became the sixteenth rector in September 2010. He has continued in the spirit of Horsley and is very involved in the diverse community that the church now serves, particularly in helping the homeless. He also played an active role in calming tensions during the summer riots of 2011.

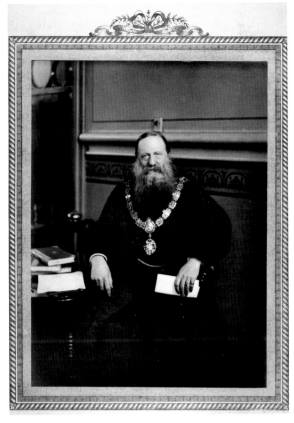

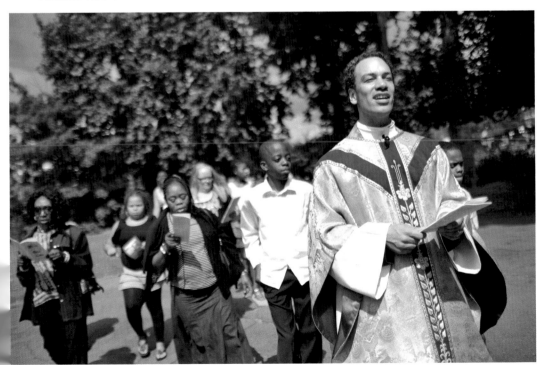

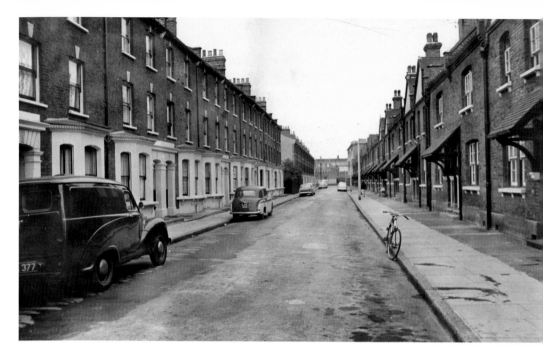

Date Street, c. 1964
Above is a fascinating photograph of Date Street, which shows housing on the left hand side of the road that has long since been demolished, with the land being absorbed into Faraday Gardens. The buildings on the right are as you will find them today, making up one of the nicest streets in the area.

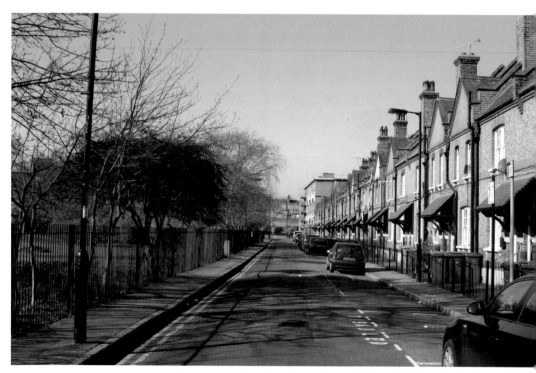

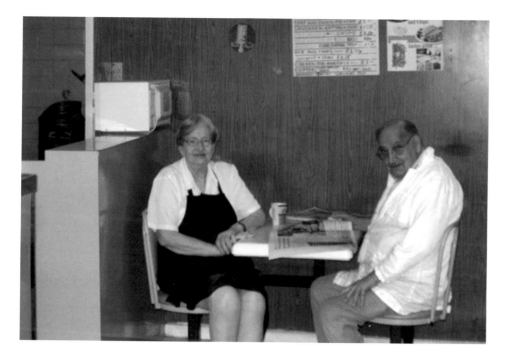

Sea Breeze Fish Bar, 1 Westmoreland Road, _c._ 2008

Opened in 1967, this shop has changed very little from its first day of trading. This was a traditional fish and chip shop – notice here the word chips and not 'fries'. It provided an eat-in restaurant or take-away service. All the usual fare was available there; cod, rock and plaice, as well as battered saveloys, pickled onions and pickled eggs. The shop appeared as a location on the television show _Ashes to Ashes_. Rumours that Clint Eastwood had a saveloy and chips when filming down Westmoreland Road in late 2009 can't be confirmed. Sadly, like so many of the older establishments in the area, the Sea Breeze closed for good in 2011.

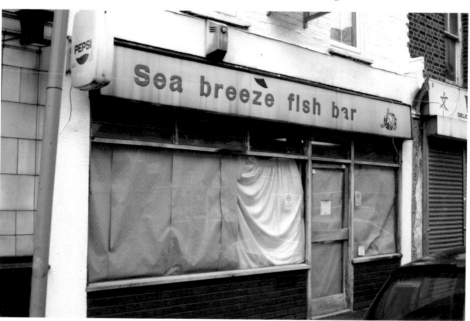

Southwark Resource Centre – 10 Brandenham Close SE17, c. 2009
October 2011 saw the official opening of the Resource Centre with a Walworth
Family Day. Bands, DJs and street performers provided the entertainment. Local
businesses also came along to add to the community spirit. This was all part
of the regeneration of the vast Aylesbury Estate, part of which was demolished
to make space for the centre – the new home for the Southwark Disablement
Association, which provides support for adults with various disabilities, as
well Southwark Councils adult social care team. New flats in and around
Westmoreland Road, Boyson Road and Red Lion Row, built by developers
L&Q, have also been occupied, including Hitard Court, a name chosen by local
residents in honour of the court jester Hitard who in 1015 was given the area
of Walworth by King Edmund Ironside. More new street names will also be
selected by those living in the immediate vicinity as part of an initiative by the
local Creation Trust, headed by Charlotte Benstead. Eventually a total of 840
new homes are planned as part of the Albany Place development.

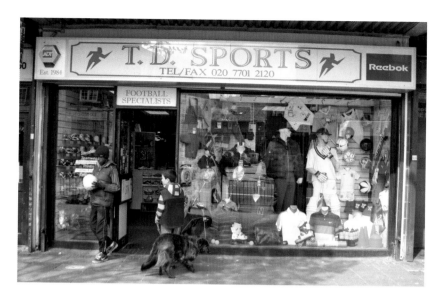

T. D. Sports, 378 Walworth Road, *c.* 1990

Opened in 1984 by Colin Dickson, this is a well-loved sports equipment shop. Dave Cox joined Colin in 1990. It has a vast range of football equipment and accessories on two floors. The day to day running of the shop is now overseen by Dave and colleague Graham Francis, with Colin now retired. Over the years the shop has been visited by many well-known footballers including Kerry Dixon, Rio and Anton Ferdinand and old Millwall favourite Gary Alexander. Perhaps the strangest visitor to the shop was singer Robbie Williams who popped in one day to check out the football stock. He was so excited by what he found that he forgot his socks when leaving! Sadly, during the 2011 riots the shop was severely looted and much of the stock was lost. However, Dave recounts how touched he was by the arrival on the morning after of volunteer 'riot wombles', with Father Andrew Moughtin-Mumby of St Peters among them, who helped to sweep up all the broken glass and get the shop on its feet again.

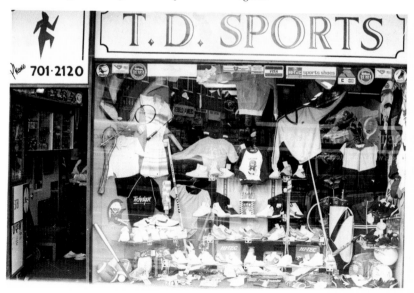

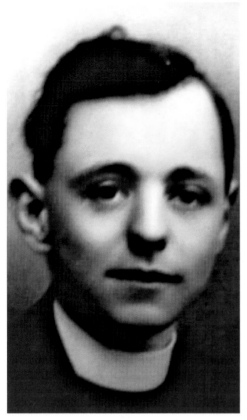

Clubland, 54/56 Camberwell Road, 1930s and 2010

From when it was opened in 1939 by Queen Mary until its closure in 1977, Clubland was described by many, as the greatest youth club of all time. It provided thousands of youngsters from the immediate surrounding area with a place to learn, debate, exercise and be creative, all within a Christian environment. It was founded by the Reverend Jimmy Butterworth (1897–1977), a Lancastrian who arrived in Walworth in 1922 to preach and work from the Wesleyan church, which had stood on this site from 1813. Within a short while of his arrival, Butterworth decided to reach out to the local youth and provide them with 'a house for friendship for boys and girls outside any church'. Demolition of the old church took place in the mid-1930s and a new building, which included a new church and a hostel, was designed by Edward Maufe. Sadly, enemy bombing in the Second World War destroyed much of the building. However, Butterworth simply set about raising funds to rebuild. His sterling work was recognised nationally when he was the subject of the *This Is Your Life* programme in 1955.

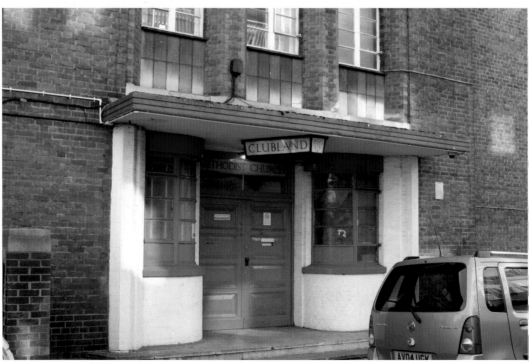

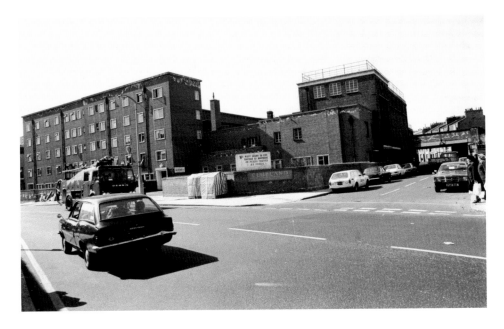

Clubland, *c.* 1978 and 2012

Butterworth had asked many well-known personalities from the world of show business to become patrons of the club and he was continually endeavoring to make it bigger and better. The likes of comedian Bob Hope, and actors John Mills and Laurence Olivier were among those who lent their name to the cause. Clubland was re-opened fully in 1964 by the Queen Mother. Sir Michael Caine began his acting career here aged fourteen as a member of the Clubland Theatre and a thirteen-year-old Bobby Kennedy gave his first speech there in 1938 whilst visiting with his father, then the US Ambassador to the UK. Butterworth retired shortly before his death in 1977. The Walworth Methodist church is thriving today, with an average weekly attendance of 350, mostly from the West African community.

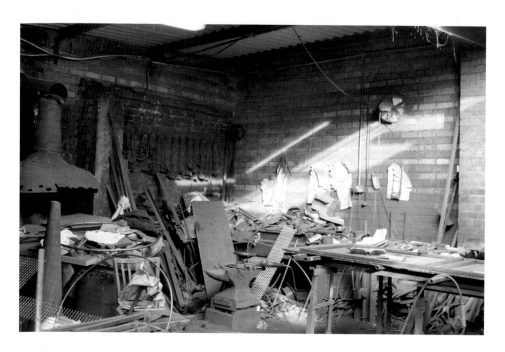

Benbow's Metalworks, Townley Street SE17, c. 2005

Started in 1875 by brothers, W. I. Benbow & A. H. Benbow. At the time they lived at 106 and 108 Brandon Street, which backed onto the workshop and its stables. They mainly worked to maintain barrows for the surrounding street market traders, especially their wheels. As well as making and repairing for those locally in East Street and Westmoreland Road, the Benbow brothers were well known all over London, in places like Brixton and 'The Blue' in Bermondsey. At one time they estimate they were working on over 400 barrows a month. The company has also worked on the ceremonial coaches of the Queen and London's Lord Mayor. Cousins Steven Benbow and Danny Mac today run the company.

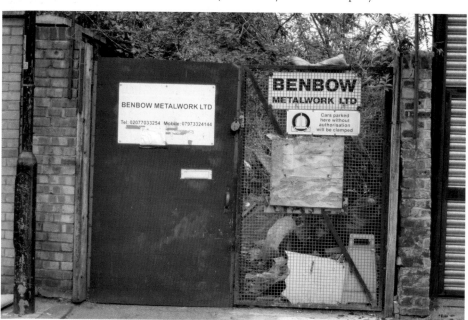

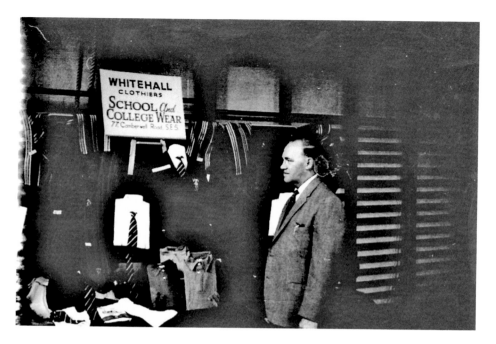

Whitehall Clothiers, 77 Camberwell Road, 1950s

The company has been supplying schoolwear since around 1900 and trading in Camberwell since the 1930s. As well as stocking uniforms for all the local schools, they also sell a range of fashion clothing. In the 1980s, when the 'casual' cult was at its height, the shop in SE5 cornered the market with its extensive range from the clothing companies of Fila, Sergio Tacchini, Lacoste and Diadora. The manager of the shop, Will, remembers queues of young boys and men along the street wanting the latest colours and styles to wear. In recent years, the shop has returned to its uniform trade, being particularly busy in the months leading to the start of a new school year.

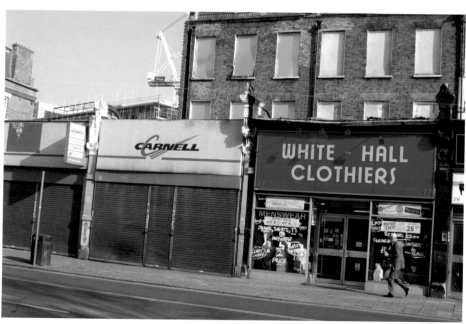

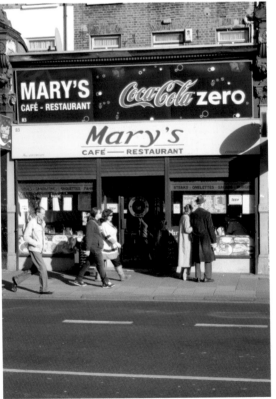

Mary's Café , 83 Camberwell Road SE5, c. 1966

A legendary café in the area, which serves a fantastic breakfast and fine food all the year round. Known as the Orange Café in the early 1960s, the Mustafa family has owned it since husband and wife Celal and Nejla arrived from Cyprus and opened it as The Istanbul Restaurant in 1965. Their daughter Mary worked there also and gradually the regulars began to know it as Mary's. Today, their son 'H', his wife Tish and brother Hassan run it. They have a dedicated group of regulars from a wide range of backgrounds, and it is a proper community café.

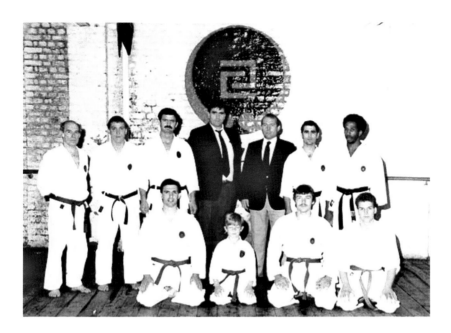

The Marble Factory, 34 Camberwell Road, c. 1980s

All that is left now are white, hand-painted words on a black alley wall. But in the 1970s those words indicated you had arrived at one of the most respected training centres in the martial art, Karate. The alleyway led to a set of steps that took you up to a training hall with a polished wooden floor. The Dojo –which in Japanese means 'place of the way' – opened in 1974 and at its height it was training a thousand students a year. Classes were available for men, women and children, from beginners to black belts. Fondly remembered senseis (masters or teachers), include Andy and the legendary George Andrews, a 7th Dan black belt. The building was destroyed by fire in 1998, which started in the garage beneath it. When erecting the new 'luxury' apartments that stand on the land, builders found hundreds of unpolished and unfinished glass 'street' marbles in the rubble.

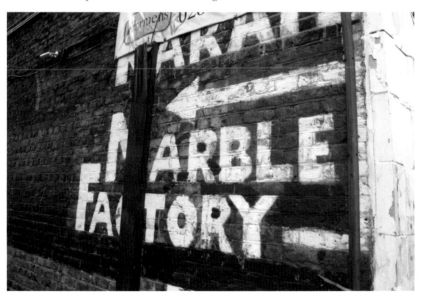

Addington Square SE5, *c.* 1905

A lovely oasis of calm in the middle of a thriving urban locale, Addington Square has been a conservation area since 1971. The large townhouses surround a garden square, which is kept in tip-top condition with colourful floral bedding displays, especially in the summer. An outdoor swimming pool opened here in around 1822, closing in 1900. The upholstering firm of A. V. Fowlds has been at no. 3, on the corner of Kitson Road, since 1926, with the business in existence since 1870. Two pubs once stood here, the Army and Navy, and the Anchor and Hope. No. 33 was once a scrapyard and private drinking establishment called the Addington Club, owned by the Richardson brothers. The tennis courts of Burgess Park are to the north of the square.

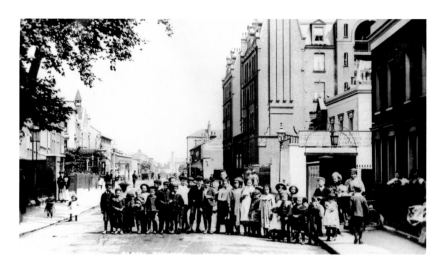

Evelina Mansions, New Church Road SE5 *c.* 1900

This lovely old five-storey mansion block, consisting of eighty-three one and two bedroom flats, was built in 1900 by the Four Per Cent Industrial Dwellings Company which was founded by Nathaniel Mayer Rothschild and other Jewish philanthropists in 1885. Its intent was to improve housing and ease overcrowding among the poor of the East End, particularly among Jewish women. The scheme then broadened out to include other areas of London, including Southwark. The majority of the tenants in the various housing developments were new arrivals from Eastern Europe, though over time the residents became mixed. Many of the tenants from Evelina Mansions originally worked on or around the Grand Surrey Canal, which although it was filled-in in the 1960s can still be traced in parts of nearby Burgess Park. There is conjecture as to the origin of the 'four per cent' part of the company's name. Some say it was the interest rate that was aspired to on the properties and others say that it indicated the number of Jews in the UK population at that time. The company changed its name to Industrial Dwellings Limited in 1952 and it still retains strong links with the Jewish community.

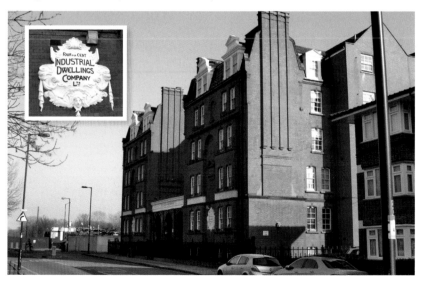

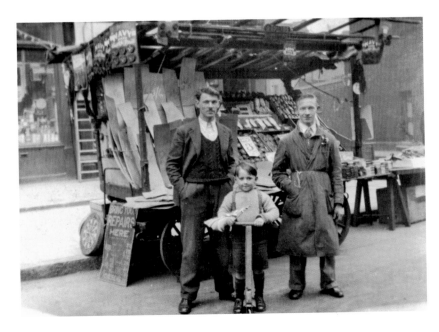

Men's Traditional Shoes, 171 Camberwell Road SE5, 1930s

A shoe shop has been at these premises since the 1850s. Some original fixtures remain intact, such as the mirrors on one wall, which were once part of the booths in which Victorian ladies would enter when trying on shoes. They would then close the curtain behind them, preventing anyone from seeing a glimpse of their ankle, which at the time would be considered extremely indecent. The family of the present owner, seen above as a young boy with his Uncle Ernie in the late 1930s, has had the shop since the 1950s. His family ran the 'shoe stall' on The Cut market in nearby Waterloo. The current shop manager is the local legend Fred Harris, known to all as 'Fred the Shoe'. He stocks all the classic English brands, Church's, Loakes, Trickers etc., as well as American styles by the company Bass Weejun.

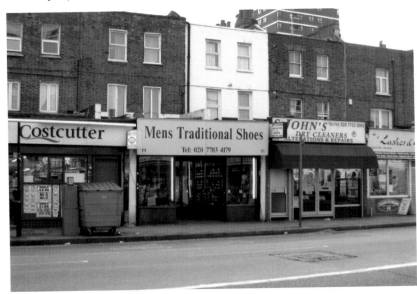

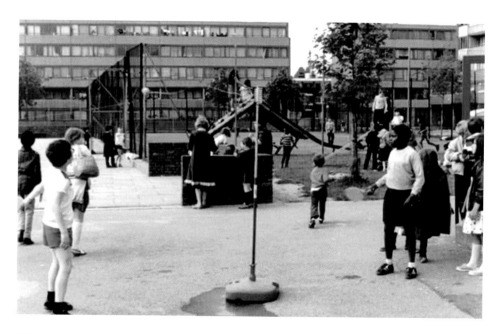

Michael Faraday Primary School, Portland Street SE17, 1980s

The year 2010 saw the re-opening of the Michael Faraday primary school for children aged from three to eleven. Once a solid Victorian building, it has been transformed with an award winning architectural design by the company Alsop Sparch. The estimated £9 million project is all part the ongoing Aylesbury Estate regeneration programme. Named after locally born eminent physicist Michael Faraday (1791–1867), the school stands on the corner of Portland Street and Hopwood Street. During building work in 2007 the Museum of London conducted an archaeological dig on and around the site. Victorian slate pencils were among the artefacts found. A recent Ofsted inspection was passed with flying colours, with the school being described as 'outstanding in all areas'. As well as its academic goals, the school aims 'to give the children a sense of social responsibility and respect for others'. Amen to that.

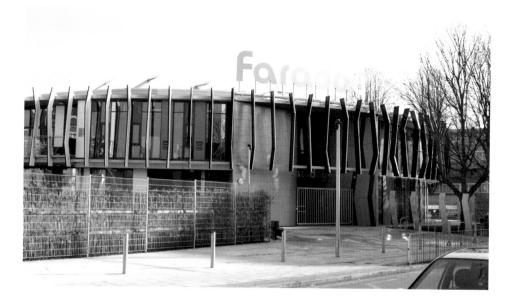

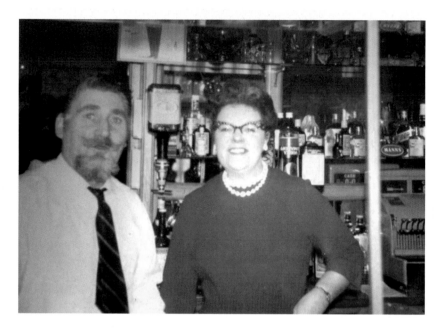

The Hour Glass, formerly 89 Faraday Street, now 131 Beaconsfield Road SE17, 1970s

Joe and Kath Hill ran the Hour Glass pub from 1965 to 1985. It once stood in Faraday Street – a street which is now long gone. The pub moved to Beaconsfield Road towards the end of the 1960s and is part of Michael Faraday House, close to the Aylesbury Estate. Above the pub, there is now a one-star budget hotel. The rooms and facilities are basic, but ideal if you are travelling on a budget. There are eight rooms over three floors. The 343 and 42 buses that stop nearby in Thurlow Street provide good links to the Elephant and Castle and the City of London.

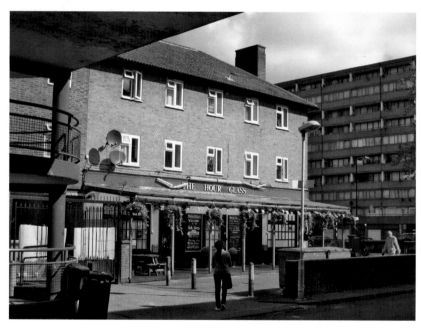

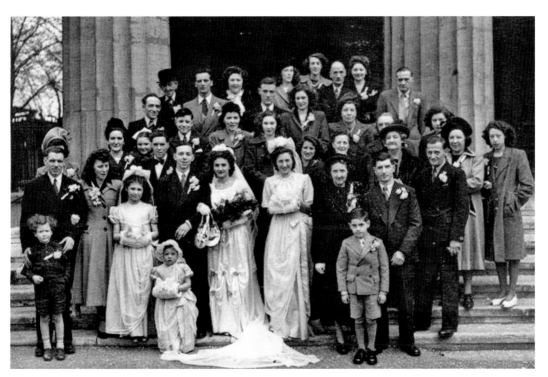

St Georges Church, 55 Wells Way SE5, 1940s

Built between 1822 and 1824 by local architect Francis Octavius Bedford at a cost of £16,000, this is an imposing Grade II listed building. A large church was required due to the rapidly expanding population of the area in the early 1820s. It has a Doric portico and large tower. A bronze memorial to the fallen of the First World War, by Arild Rosenkrantz, stands at the front of the building. Wreaths are still laid upon it every November on Armistice Day. This was a very active church at one time, administering baptisms, marriages and burials. It was declared 'redundant' in 1972 and deconsecrated in 1976. It was constantly under attack by vandals during this period and a fire destroyed the interior in the early 1980s. Its congregation moved to a new St Georges church in nearby Coleman Road in 1983. The old church was re-developed between 1992 and 1994 by the St Georges Church Housing Co-operative to provide thirty one-bedroom flats. The homes are on three levels surrounding a central courtyard. The former church grounds provide off-street parking.

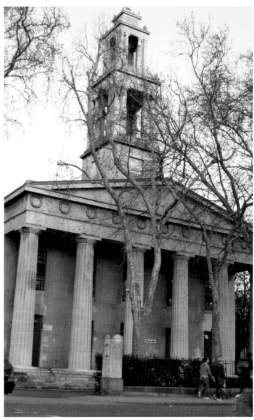

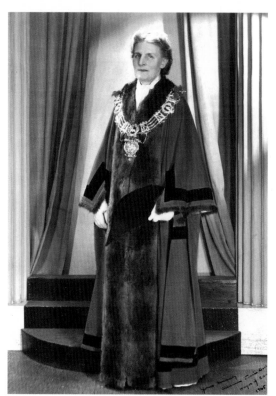

Burgess Park SE5 and SE1, 1960s and 2012

Covering an area of thirteen acres, this vast park stretches from Camberwell Road to the Old Kent Road. Old housing stock and industrial units previously occupied the land that the park is now built on. The scheme for the park began as far back as 1943, as part of the Abercrombie Plan to rebuild London after the bomb damage of the Second World War. Huge swathes of land were acquired and landscaped in the coming decades. The Grand Surrey Canal, which served the Surrey Commercial Dock and which ran through part of the area was closed in the early '70s. Named after the area's first lady Mayor, Jesse Burgess, seen left, the park contains listed buildings, including the almshouses, some of which now house a café, and public washhouses that are home to The Lynn, London's oldest amateur boxing club. There is a large fishing lake as well as tennis courts, football and cricket pitches, and a popular outdoor gym.

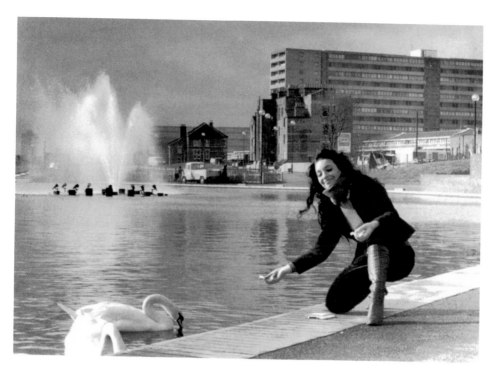

Burgess Park, 1970s and 2011

Each year, large musical events and fairs take place in Burgess Park, including the Carnaval Del Pueblo that since 1999 has been held annually to celebrate the culture of Latin America. In March 2009 the park was awarded a £2 million grant from the Mayor of London, Boris Johnson, which was then upped to £6 million by Southwark Council. This money will renovate and upgrade the park's lighting, play areas, footpaths and toilet facilities, along with general re-landscaping. The majority of the park closed in October 2011 for the duration of the rebuild and opened again in April 2012.

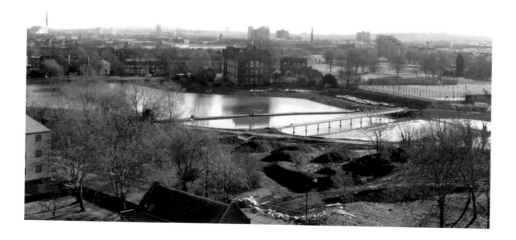

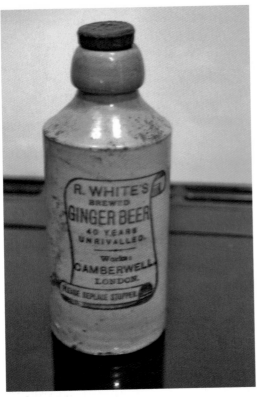

R. Whites and Sons, Albany Road SE5, c. 1910

The famous carbonated lemonade drink began its life in Camberwell in 1845. Made by Richard and Mary White, it was originally sold from street barrows. The drink proved immensely popular and the company quickly expanded. By 1869, it had five production factories and sixteen depots around the South East and the Midlands, including the 'works' on both sides of Albany Road SE5. Other drinks that the company is associated with include Ginger Beer and Cream Soda. The Camberwell factory closed in 1969 to make way for part of the new Aylesbury housing estate. The R. Whites Company was bought by Whitbread in the same year, operating from a new building in Beckton, East London. The business was absorbed into the giant Britvic Corporation in 1986. Many children of the 1970s remember fondly the 1973 'Secret Lemonade Drinker' television advert for R. Whites, which featured a song sung and written by one Ross McManus, father of pop performer Elvis Costello, who provided the backing vocals.

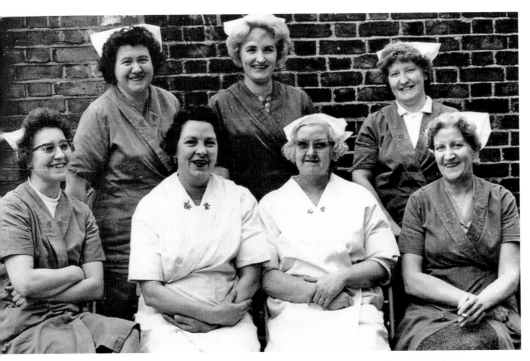

Walworth School and Academy, Trafalgar Street SE17, Mina Road SE17 and Shorncliffe Road SE1, 1960s
Mina Road School was established in the early 1880s and this changed its name to Walworth School in 1946. It was known then as an 'experimental' comprehensive. Judged to be a success, it proved instrumental in many changes in the education system in London from then on. Fondly remembered dinnerladies from the school in the 1960s can be seen above. By the 1970s, many of the pupils came from the nearby Aylesbury Estate and the school eventually held over a thousand pupils. This was known as the upper school. The lower school stood in Trafalgar Street on the site of what was once the Sanford Road School, built in 1891. The Walworth Academy, run by the UK-based charity ARK (Absolute Return for Kids), replaced the old school in 2007. It is a mixed school with pupils aged from eleven to eighteen. A Southwark Council people's choice blue plaque was erected at the academy in 2010 to honour Anne Winfrede O'Reilly (1891–1963) who was the progressive headteacher from 1947 to 1955.

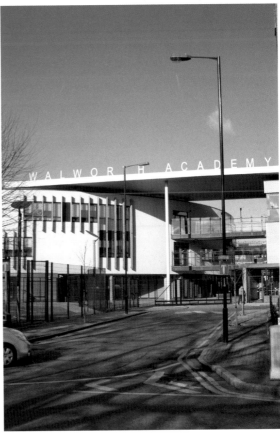

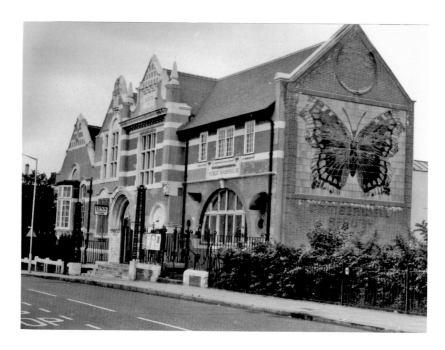

The Passmore Edwards Library and Public Baths and Washhouse, Wells Way SE5, 1980s

Victorian philanthropist John Passmore Edwards (1823–1911) bequeathed money for the library that bears his name, standing on land given by Lord Llangattock, as noted by the foundation stone on the site. Designed by Mr Maurice B. Adams in 1902, it stands next to a Public Bath and Washhouse. Warm baths opened here in 1903. Baths and washhouses were introduced to Britain in 1828 in an effort to improve hygiene among the poor. The buildings are Grade II listed, along with the chimney behind them. On the south side of the bath's wall, you will find a large tiled depiction of the Camberwell Beauty, a one-time common local butterfly. The tiles were originally attached to a building owned by the 'gummed paper' merchants Samuel Jones in nearby Southampton Way . The library is now empty, but the baths house the Lynn Amateur Boxing Club, which was founded in 1892 at the Sausage, Potato and Onions Café at The Borough. The club moved here in 1981 and is sponsored by local firm Pimlico Plumbers. A Pentecostal church has also set up home here.

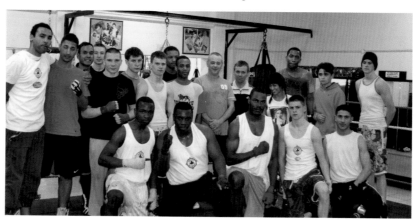

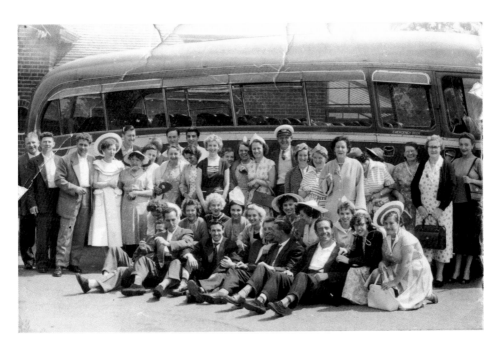

St Michael's Eritrean Orthodox Church, 78 Edmund Street, c. 1955

Perhaps this address reflects the changing pattern of life in Camberwell more than most. At one time, the Rose Public House stood here. It had a function room with a stage, upon which many a 'pub' singer performed. After being vacant for a few years, the building later became DebreSahl St Michael's in the late 1990s. The Eritrean community first arrived in the UK in the early 1960s, and a second wave followed in the late 1980s and early 1990s, around the time of the country gaining independence from Ethiopia. The aims of the church are to provide a place of worship, but also to provide education in the mother tongue thus helping to preserve cultural identity. On any Sunday morning you can see many worshippers arriving dressed in white robes.

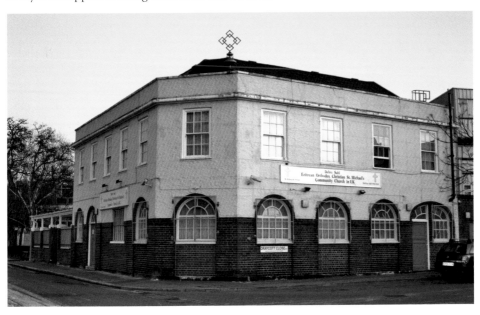

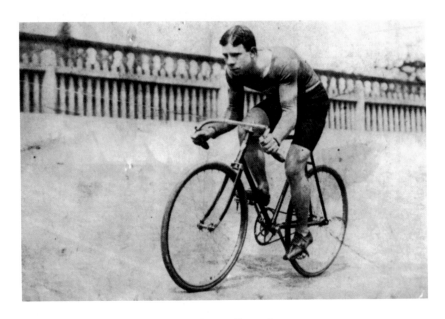

Edwardes (Camberwell) Ltd, Camberwell Road SE5, c. 1904
One of the oldest established firms in the area, this bicycle shop opened in 1908.
The owner then was Harold Arthur Edwardes, known to all as 'Jack', who can be
seen in action above. Jack was actually selected for the 1904 Olympics, which took
place in St Louis, Missouri, but the story goes that he couldn't take part because
he was under twenty-one at the time and thus too young to obtain a passport.
The shop was originally at 277–279 Camberwell Road, and moved to its present
site in 1955. The Edwardes family also had a smaller shop in Westmoreland
Road and they were awarded a warrant for the supply of mopeds to the royal
household. It is still a family business, run today by Gary, Carol and Clark. This
triple-fronted shop has over a thousand bikes on display, including track, BMX
and mountain styles that will appeal to all ages. There is also a thriving second-
hand section, and every conceivable accessory for your cycling needs.

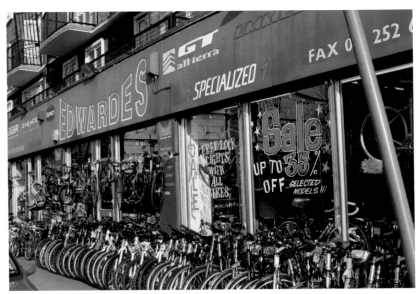

The Camberwell Public Baths, Artichoke Place SE5, c. 1900

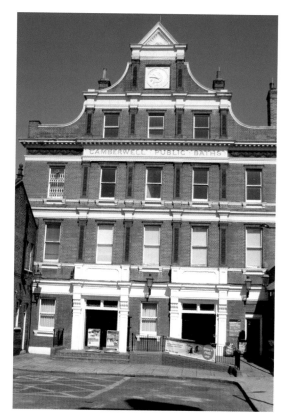

This Flemish Renaissance style building, by builders Balaam Brothers, was opened in October 1892 at a cost of just under £30,000. Originally it housed two large swimming pools, sixty-four private baths for men and thirty-two baths for women, with seventy-eight public laundry compartments. The pools could also be boarded over and converted for use for other sports, such as five-a-side football, cricket and tennis. Concerts and other social events also took place here. Many a local school child learnt to swim at Camberwell Baths and it was very popular during the annual six-week holidays. Sadly the baths were in a bad state of repair towards the end of the 1990s and were under threat of closure. The building itself attained a Grade II listing in 1993. The 'Friends of Camberwell Baths' was set up in 1998 to save the baths and they were eventually successful after a long campaign. It closed in late 2009 for refurbishment and reopened as Camberwell Leisure Centre in March 2011. It has one twenty-five-metre pool, as well as a popular café, gym and facilities for badminton and other sports.

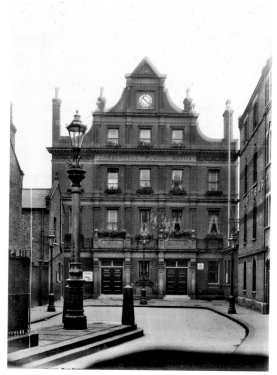

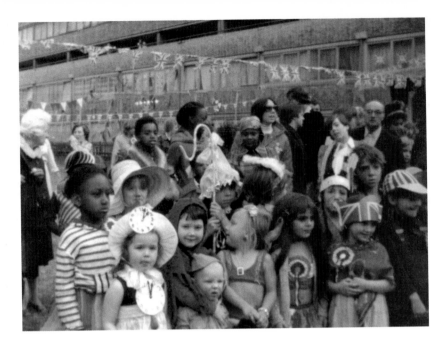

Silver Jubilee/Diamond Jubilee of Queen Elizabeth II, c. 1977

The photograph above is from 7 June 1977. It shows residents from the Aylesbury Estate, enjoying a street party to mark the Silver Jubilee of Queen Elizabeth II. This would have been one of over 4,000 such street parties that day in London alone. Bunting was hung from every conceivable vantage point as streets and villages all over the country turned out to mark the occasion. In 2012, to mark the Queen's reign of sixty years, Diamond Jubilee celebrations are planned on 2–3 June, with Bank Holidays on the 4–5 June. Once again many street parties will be in full swing amongst the official and state occasions, such as a music concert at Buckingham Palace and a Thames Pageant in which a thousand boats will converge on the famous old river.

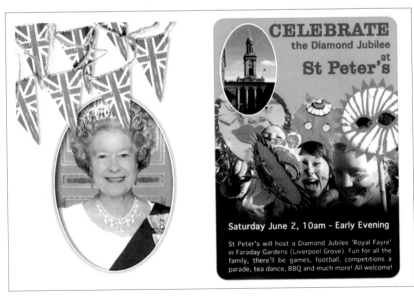

The Ship – 171 Kennington Road, *c.* 1993

A pub has stood here since around 1780, but it had a major rebuild around the 1860s. It stands on the corner of one of Kennington's loveliest areas, namely Walcot Square. To walk through this and nearby Cleaver Square is to almost take a step back in time. Rows of houses erected between 1837 and 1839 surround a green 'square' of grass. The Ship has a claim to cinematic fame. It appeared in the 1971 British film *Melody*, which reunited actors Mark Lester and Jack Wild from the film classic *Oliver*. In this film, Melody, played by Tracy Hyde, can be seen at one point outside The Ship talking to her dad, played by fondly remembered actor Roy Kinnear. With a soundtrack by the Bee Gees, the film has now become a cult classic – particularly in Japan, bizarrely enough!

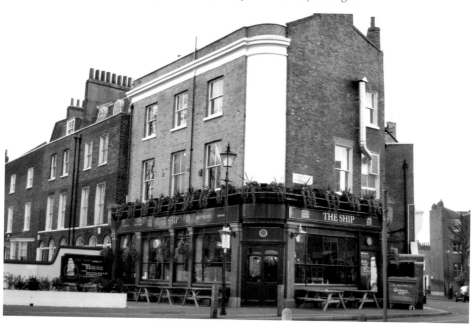

Kennington Cross SE11, c. 2004

Gentlemen's public toilets and animal water troughs like the ones found here were once a familiar site on high streets all over town. These two fine examples of Victorian London are situated by the extremely busy crossroads at Kennington Cross. The conveniences are from around 1900 and were built as part of the 1891 Public Health Act. They are no longer in use, but down the stairs there are ten urinals as well as wooden cubicles, all fitted by the Lambeth company B. Finch and Co. Nearby there stands a stone drinking trough for cattle inscribed 'Metropolitan Drinking Fountain & Cattle Trough Association'. There is also a lower dog trough. Local residents tell us that at one time, there were plans to turn the toilets into an art gallery, though there is no sign of this at present.

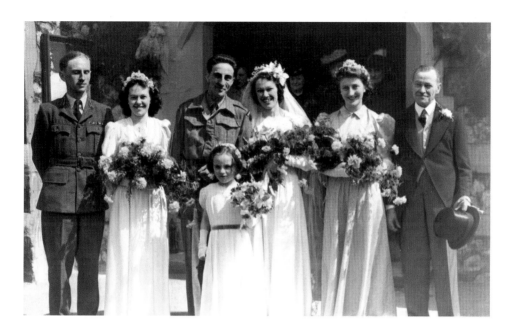

St Philip's Church, Kennington Road SE11, c. 1947

Built in 1863, this was once a thriving North Lambeth parish church with a dedicated congregation. The original architect was H. E. Coe. He designed a fourteenth-century-style building with a rag stone frontage, complete with spire. A choir vestry and a new pulpit were added in 1913. The wedding shown is that of Mr and Mrs Nicholson, who lived in nearby Walcot Square. By 1960 some of the building was in need of repair and the spire was replaced with a copper roof. The interior was refurbished in 1962, but due to structural problems by 1974 it could no longer be used. The congregation initially moved to the adjoining Archbishop Sumner School. The last service in the school was in early 1989 and then they moved onto other churches in the area, including St Anselm's and St Peter's. St Philip's was demolished in 1976. Its grounds are now home to a nature garden used by the pupils of the school.

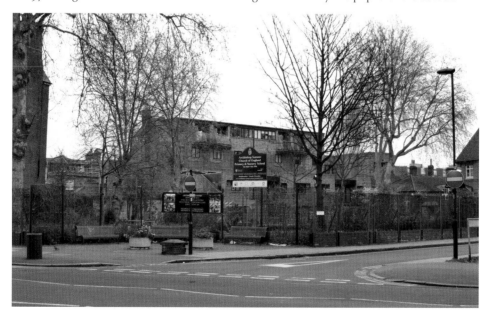

The Durning Library, 167 Kennington Lane SE11, *c.* 1990

This impressive Victorian library is by builders Hall Beddall & Co. from a design by architect Sidney R. J. Smith, the designer of the original Tate Gallery on Millbank, for regular client, sugar merchant and philanthropist, Henry Tate. Costing £10,000, this 'North Italian Gothic' construction opened on 6 November 1889. It was one of the first public libraries in Lambeth, a gift to the area by Jemima Durning Smith. It is still a functioning library today, much loved by its many regulars. A collection of books left by travel writer Eric Newby, who once lived locally, has been donated to the library by his wife Wanda.

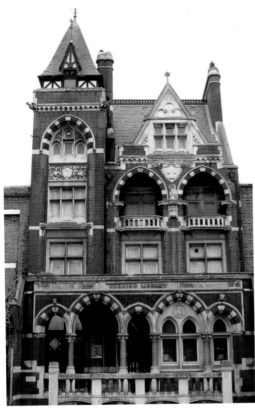

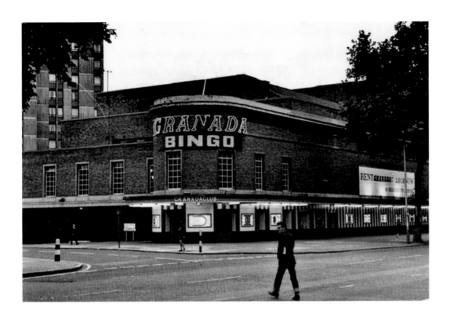

Granada Cinema, Kennington Road SE11, c. 1970s

Building work began on the Regal cinema in 1932, designed by Bertie Crewe in association with Henry Kay and a consultant from the Duchy of Cornwall, Louis de Soissons. Built for the Arthur O'Connor cinema chain, it opened in November 1937. Designed as a split-level theatre-cinema, it seated 2,000 paying customers. Its canopied entrance on the corner of Black Prince Road became a well-known local landmark. In 1949, it was taken over by the Granada Theatres Ltd. It closed as a cinema in July 1961 with *Genevieve* and *Doctor At Large* being its last two films. It would soon become a Granada Bingo Hall, as well as featuring wrestling on Saturdays. It became The Gala in 1991, eventually closing in early 1997. For the next five years, a local church used the building and then the auditorium was demolished in mid 2004 and sixty-two flats were built on the site, though the original entrance and façade was retained.

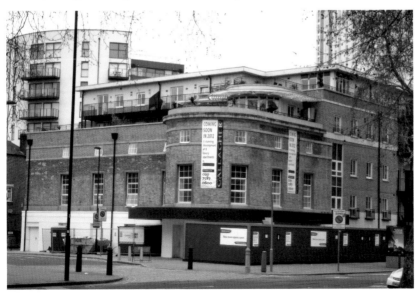

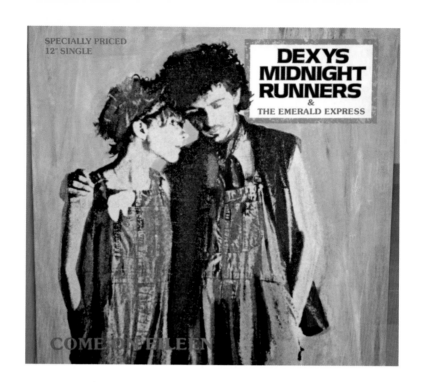

Dexys Midnight Runners, Brook Drive SE11, 1982

Here's a nice little curio: the filming for the video of the song 'Come On Eileen' took place here in 1982 in Brook Drive on the corner of Hayles Street, near the Elephant and Castle. The group and front man Kevin Rowland can be seen dancing away outside the corner shop Vi's Stores, now called Brook Drive Mini Market. The lead female in the video is Maire Fahey, sister of Siobhan who found fame with the group Bananarama. Once there were many little shops in this part of Kennington and they were often used as film locations, including one in nearby Walcot Square that was used in the 1990 film *The Krays*. Many of the shops and pubs seen in the surrounding streets have now been converted into apartments.

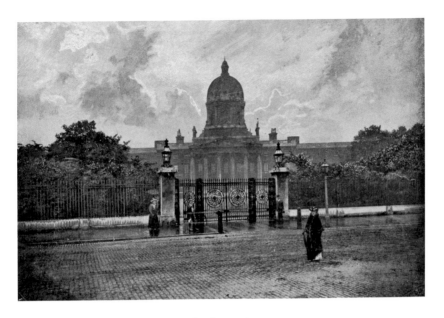

The Imperial War Museum, Lambeth Road, *c.* 1900

This museum began life in 1917. It was originally housed in the Crystal Palace on Sydenham Hill. Due to lack of space it moved to the Imperial Institute in South Kensington in 1924 before setting up permanently here on Lambeth Road in 1936. The building once housed the Bethlem Royal Hospital, known locally as Bedlam. James Lewis built the hospital in around 1814, with the dome and portico later added by Sydney Smirke. It stands in the eighteen-acre Geraldine Mary Harmsworth Park. The park is named after the mother of the first Viscount Rothemere, who donated the grounds to the London County Council and 'the splendid struggling mothers of Southwark' in 1936. The park includes a Soviet war memorial and a Tibetan peace garden, which was opened by the fourteenth Dalai Lama. The collection housed here includes military vehicles of all shapes and sizes, from First World War tanks to Spitfires, extensive libraries of books, photographs and video recordings, as well as a respected art collection.

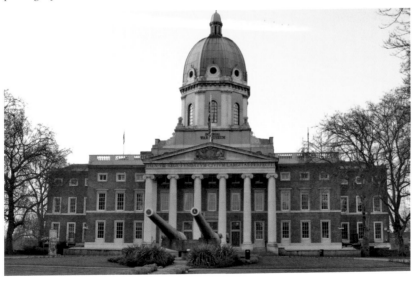

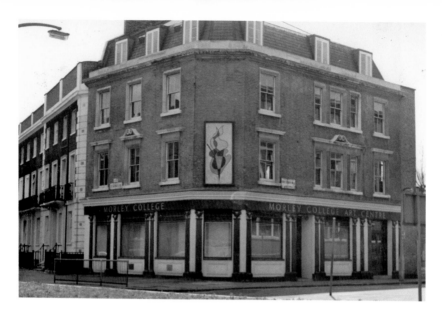

The Morley College, 1970s

In 1880, social reformer Emma Cons took over the lease on the Royal Victoria Hall (now The Old Vic) and began a series of 'morally decent' temperance meetings, opera recitals and lecture. The 'penny lectures' were hugely popular and led in turn to funding from Samuel Morley MP who was impressed by the equality shown to gender and class at the meetings. This financial assistance led in 1889 to the establishment of The Morley College for Working Men and Women. By 1920, the Morley College moved to nearby Westminster Bridge Road. Its original building was badly damaged by bombing raids in 1940 and then rebuilt and reopened by the Queen Mother in 1958. The college now provides an extensive range of evening, day and weekend courses in music, art, language, fashion and dance amongst many others. A nearby pub was converted as an art gallery in 1968. Over the years staff members have included Gustav Holst, Ralph Vaughan Williams and Sir Michael Tippett. Students have included writer Virginia Woolf, artists Maggi Hambling, David Hockney and Bridget Riley, and local actor Johnny Harris.

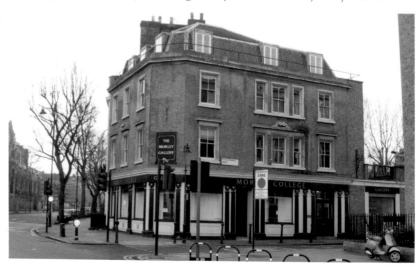

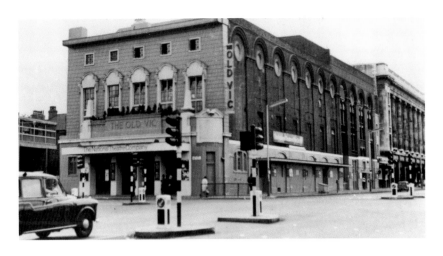

The Old Vic Theatre, The Cut SE1, *c.* 2007

This world-renowned theatre is a short ten-minute walk from the Elephant and Castle shopping centre. It opened as The Royal Coburg in 1818. A name change in honour of future Queen Victoria saw it become The Royal Victoria in 1833. It closed and re-opened in 1871 as The New Victoria. In 1884 it became the forerunner to Morley College, providing evening classes for men and women. Lillian Bayliss, the twenty-three-year-old niece of Emma Cons, became acting manager in 1898; her productions included classic operatic and Shakespearean works. By 1936, theatre greats such as Edith Evans, Sybil Thorndike, Peggy Ashcroft, John Gielgud, Ralph Richardson, Alec Guinness and Laurence Olivier were all part of the company. Badly damaged by a bombing raid in 1941, a new established 'Old Vic School' emerged from the ruins. Olivier was appointed director of the new National Theatre in 1962, with The Old Vic becoming its home, and its own company disbanding. The next wave of acting greats, Maggie Smith, Peter O'Toole and Albert Finney among them, performed regularly here. 1976 saw the National move to its new home on the South Bank. The Old Vic was back on the market in 1982 and then again in 1998, when it was bought by impresario Sally Greene. Hollywood star Kevin Spacey was appointed artistic director in 2003, a position he still holds today.

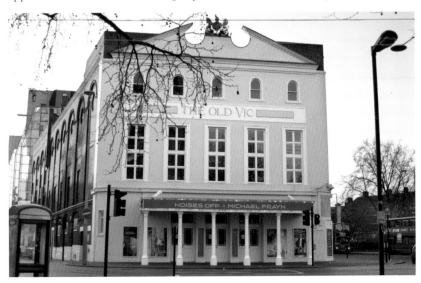

London Park Hotel, Brook Drive SE11, c. 1975

Victorian philanthropist Lord Rowton (1838–1903) founded his 'poor man's hotels', named Rowton Houses, after conducting a survey into the housing conditions of the working man. He opened Parkview House, Newington Butts in December 1897. The establishment overlooked what was the churchyard of St Mary, Newington. Just over eight hundred individual cubicles were available to men only, for the price of sixpence per night. It became the London Park Hotel in 1972, a popular tourist hotel with a fine interior, which contained a coffee shop, a restaurant and two well-stocked bars. Shoppers on the way back from the nearby shopping centre were often known to pop in for a 'livener' on their way home and its huge illuminated red sign is fondly remembered. In the early 1990s it became more of a backpackers hostel; its best days were behind it. Into the late '90s, and now owned by businessman Firoz Kassam, it housed over six hundred asylum seekers. It was demolished in 2007, and there are now plans for a new leisure centre, as well as a huge forty-four-storey tower block, on the site.

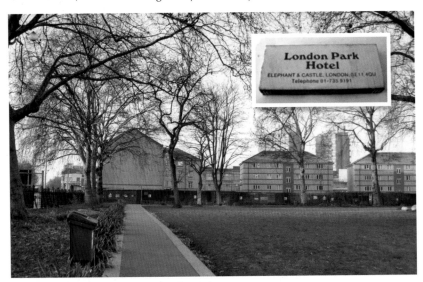

Elephant and Castle Tube Station, 70/72 London Road, 1950s

This station still looks pretty much as it did when it first opened in August 1906. The deep oxblood red faience tilework is still intact, with the name of the station picked out in gold paint. Known originally known at the Baker Street and Waterloo Railway station, it was designed in an art deco style by Leslie Green. For many years white painted letters advertising local newspaper the *South London Press* could be seen above the station. The paper, which has been in operation since 1865, had offices here, in the building still known

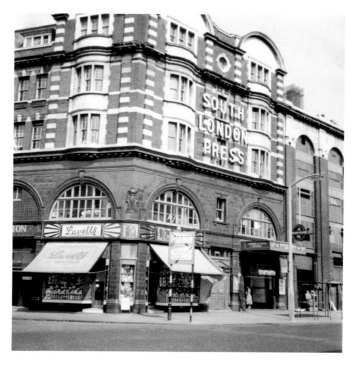

as South London House. The station services the Bakerloo and Northern lines. You enter the station through its original entrance, and exit via a modern, glass-fronted extension. The tiled mural inside the entrance depicts the immediate area in 1912. The offices above the station are now used for administration purposes and accommodation for tube drivers.

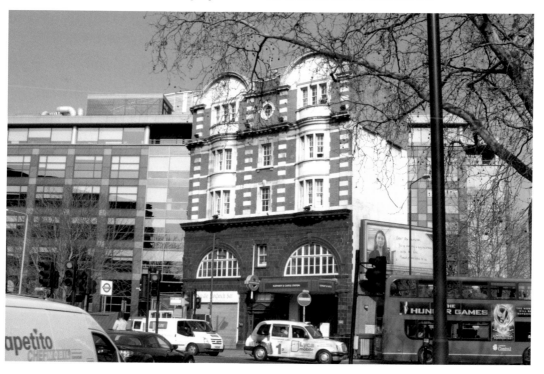

The Michael Faraday Memorial c. 1960s

This strange construction is the Michael Faraday Memorial, which is on the northern roundabout at the Elephant and Castle. Faraday, an eminent scientist, was born nearby in Newington Butts. Despite having only a rudimentary education, he rose to the top of his chosen profession. Designed by architect Rodney Gordon and built in 1961, the memorial consists of a silver stainless steel box, which fifty years on from its construction still looks very futuristic. Inside there is a London Underground substation, which services the Northern and Bakerloo lines. It is said that Gordon originally designed it to be made of glass, however this idea was shelved due to fears of vandalism. In 1996 Grade II listed status was bestowed on the memorial and in the same year a new lighting scheme for the memorial was introduced as a result of a competition run by the BBC television programme *Blue Peter*. With the ongoing regeneration of its immediate area, there is talk of it being moved to a more accessible location upon the nearby Walworth Road.

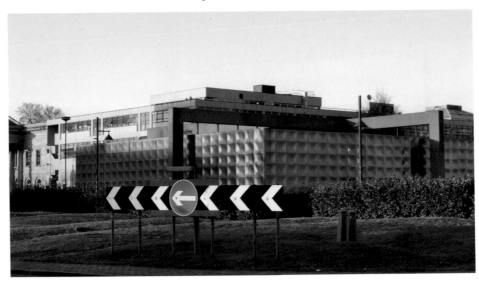

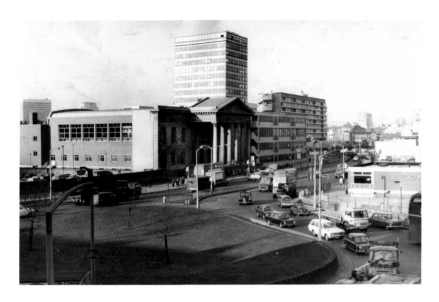

The Metropolitan Tabernacle, c. 1969

This imposing building stands in the middle of the Elephant and Castle. Home to Reformed Baptists, it can trace its origins to 1650. At one stage in the late 1700s it had one of the largest congregations in the country. However by the mid 1850s it was in severe decline. Enter Charles Haddon Spurgeon who became the most popular preacher in the UK. Such was the demand to hear him speak that services were held in the Surrey Gardens Music Hall, which help 10,000 people. Large permanent premises were needed and work began on the Metropolitan Tabernacle. Designed by William Wilmer Pocock, it seated 5,000 worshippers, with room for another 1,000 standing. The church left the Baptist Union in 1887, rather than 'downgrade' its faith, and Spurgeon died in 1892. The original building was badly damaged by fire in 1898, but the impressive portico survived. Re-built, it was once again destroyed in 1941, this time by German bombing. However, again the frontage survived and in 1957 a smaller version of the church re-opened. Congregation numbers were once again at an all-time low. Dr Peter Masters became the pastor in 1970, and numbers again began steadily to rise. Mr Masters still holds the position today.

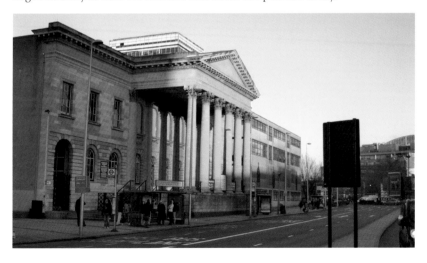

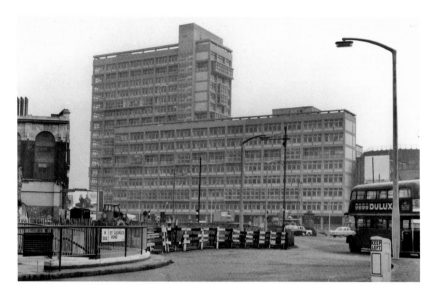

Alexander Fleming House, Newington Causeway, 1960s

Designed by Hungarian architect Erno Goldfinger (1902–1987), this award-winning group of four seventeen-storey buildings from 1960 was considered a design classic at the time of construction. Described as Brutalist in style, the buildings are made from reinforced concrete. The client was the Ministry of Health, who set up their headquarters here and named it in honour of 1945 Nobel Prize winner, Sir Alexander Fleming (1881–1955), who discovered penicillin in 1928. In 1967, Goldfinger also designed a new Odeon cinema, which sat alongside the complex. However this was no longer in use when it was demolished amid much outcry in 1988. When the Department of Health moved sites, the buildings were converted into four hundred single apartments known as Metro Central Heights and Goldfinger's original design was drastically altered. A new fifteen-storey building now stands on the site of the Odeon. James Bond author Ian Fleming took a dislike to the architect after seeing his designs while living in Hampstead, and named the villain in *Goldfinger* after Erno – one way of getting your own back, I suppose!

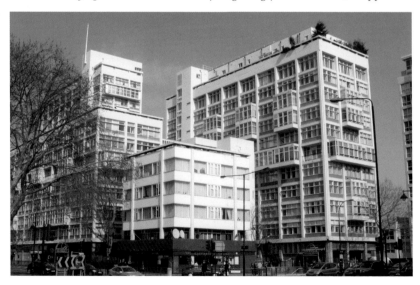

The Trocadero, Formerly 1–17 New Kent Road, c. 1958
Designed by George Coles and opened in 1930, this huge 3,500-seater cinema housed the largest Wurlitzer organ ever seen in the UK. The firm Hyam & Gale constructed this fine Italian-Renaissance-style building. It remained a major venue for cinema and stage performances for the best part of sixty years. During the Second World War a typical performance at the cinema would consist of two features, cartoons, an organ intermission, newsreel and a stage show, as well as trailers for forthcoming attractions. Many famous performers played 'The Troc' over the years, including Duke Ellington, Frank Sinatra, and Buddy Holly. With the advent of television, audience numbers dwindled and it closed in October 1963 and was demolished soon after. A smaller Odeon cinema, designed by architect Erno Goldfinger was built, but this too was demolished in 1988. A plaque to commemorate 'The Troc' and the Odeon cinema was unveiled in June 2008 by television presenter and writer Denis Norden, who once worked there.

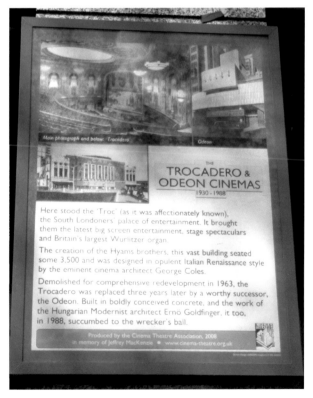

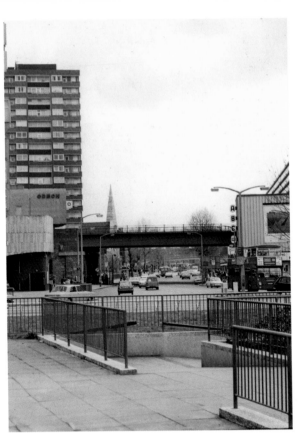

The Coronet, 28 New Kent Road SE1, 1970s

The sight of the now blue Coronet building is a familiar one to all those who pass by it on their daily journeys. The building first opened as the Theatre Royal in 1872, but this was destroyed by fire just six years later. It re-opened as the Elephant and Castle Theatre in 1879 and a young Charlie Chaplin once performed here. Frank Hatcham, also responsible for the Hackney Empire, the Hippodrome on Charing Cross Road and the Coliseum on St Martin's Lane, oversaw its re-build. The building was converted to the ABC Cinema in 1928. During the wartime Blitz, the building was used as a shelter. In the late 1960s it became a three-screen complex, and the Coronet Cinema in 1981. It finally closed for business in 1999. Since 2003 it has become a live performance space, home to music gigs, club nights and, more recently, boxing tournaments. It has the capacity for 2,600 people over three floors.

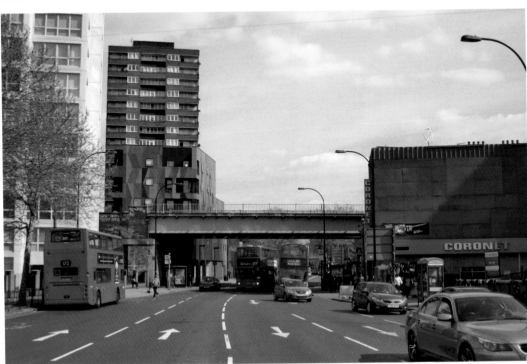

Seafood on a Sunday, Rose Brothers, 213 East Street SE17, and Bob White's, 1 Kennington Lane SE11, c. 1976

The tradition of a 'seafood tea' on a Sunday can be traced back as part of London's folklore for generations. It was a ritual to buy pints of winkles, shrimps, cockles, whelks, crab and prawns and then take those back home to peel and dress them, along with watercress and celery, in preparation for that evening's tea. Pins in hand, often a race would take place to see who could shell a winkle the fastest! All over London, seafood stalls were commonplace not only in street markets, but they were often street corners and outside pubs. White's is now the Lobster Pot Restaurant.

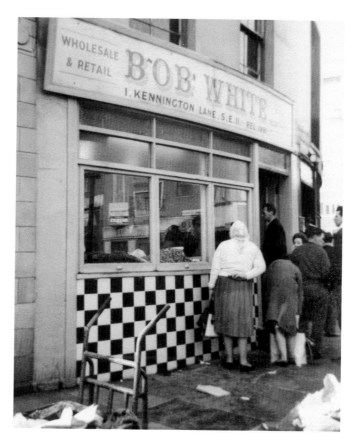

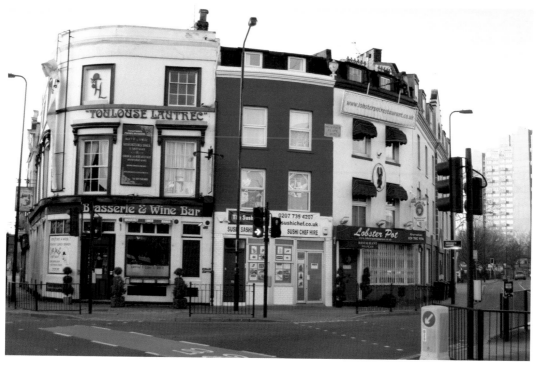

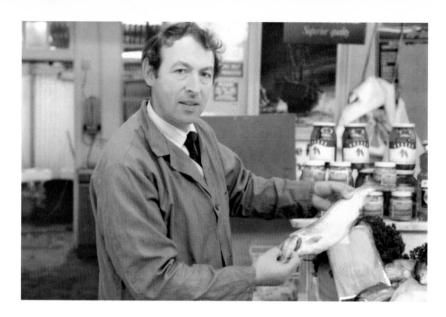

Seafood on a Sunday, Rose Brothers, 213 East Street SE17, and Bob White's, 1 Kennington Lane SE11, *c.* **1980s**

Two favourite local fishmongers were Bob White's in Kennington Lane and Rose Brothers on East Street. White's opened in 1910, with the family originally coming from Canterbury. A family run concern, it closed in 2004, as supermarkets hastened the decline of many small businesses like this. Ron Rosefield of Rose Brothers originally began his business in Bow, in the East End, but ventured south in 1963. The open-fronted shop is still in operation, and has a fine display of fresh fish and other seafood each day. Son Paul runs a wet fish stall in East Street market. A seafood stall has run from his very pitch for the past 100 years, once by legendary firm Hugmans. This tradition, like many others, is perhaps on the wane now, but you can still see a few die-hards stocking up on their seafood on Sundays.

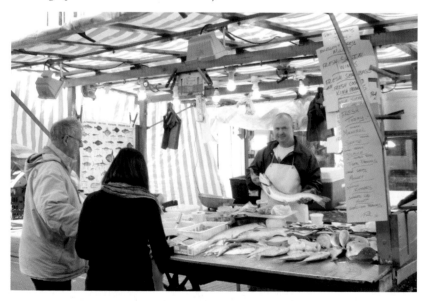

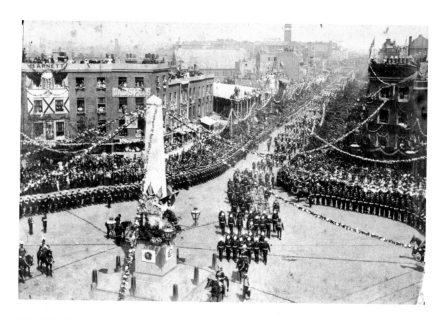

The Obelisk, St George's Circus SE1, *c.* 1897

Situated in the middle of the busy roundabout that leads traffic in and out of the Elephant and Castle area stands a Portland-stone obelisk, built in 1771 from a design by Robert Mylne. It honours one Sir 'Bold As' Brass Crosby, Lord Mayor of London at the time. Originally it had an iron collar at its tapered top, which held four oil lamps, and it was enclosed by iron railings supported by four up-turned cannons. There are many mentions of it in the works of Charles Dickens. In 1905 it was moved from this its original location to Mary Harmsworth Park, which make up the grounds of the nearby Imperial War Museum. An ornate clock tower, built to mark the diamond jubilee of Queen Victoria and provided by Messrs. Faulkner & Co., was erected in its place, but this was demolished in 1937 after it was declared a nuisance to traffic! The inscriptions at the obelisk's base inform us that it was erected in the eleventh year of the reign of King George III and that it stands a mile from London Bridge, Fleet Street and the yard of Westminster Palace. It was granted Grade II listed building status in 1950. The obelisk was returned to its original position in 1998 and 'guerilla gardeners' tend to its surrounding planting areas.

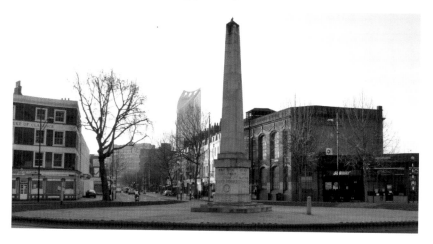

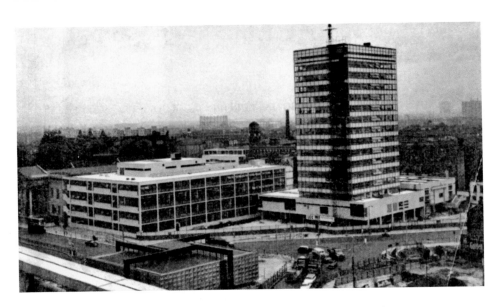

The London College of Communications, Elephant and Castle, c. 1962
This imposing building opened in 1962 as the London College of Printing, but the history of this establishment of learning can be traced back to 1894 when it was known as the Saint Bride Institute Printing School and situated just off Fleet Street. It was granted university status in 2003, thus becoming part of the University of The Arts, London. Five thousand students study on over sixty courses in design and media, incorporating photography, film and journalism. The building also comprises exhibition spaces, television studios and print workshops. Former students include Rebekah Brooks of News International fame, advertising guru Charles Saatchi, fashion designer Henry Holland and playwright Kwame Kwei-Armah. The founders of the style magazine *Dazed and Confused*, Jefferson Hack and photographer Rankin, started the magazine whilst studying here.

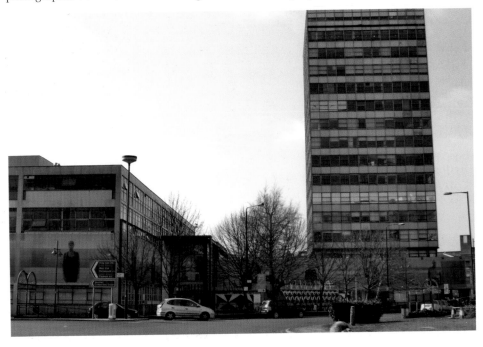

The Elephant and Castle Statue, c. 1907 and 2012

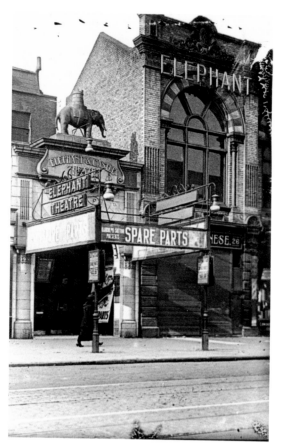

The red, yellow and grey painted bronze statue of an elephant with a castle on his back is known to all those who live locally. When the Elephant and Castle shopping centre opened in 1965 the statue was on show within the complex, but it can now be seen outside the main entrance. It was taken originally from a theatre and then from a demolished public house, which stood near to where the north roundabout and Michael Faraday memorial are today. A coaching inn called the Elephant and Castle situated in the immediate vicinity can be traced back as far as 1674. Its central location was a bonus for those travelling to Kent and Surrey. Where the name actually came from depends to whom you talk to. Some say, it's derived from a corruption of *Infanta de Castilla,* said to be Eleanor of Castille, wife of Edward I. Others say it's named after the blacksmith and cutler who was based at the old coaching inn. The sign of an elephant with castle was associated with the Guild of Cutlers. Ivory was often used for cutlery handles, explaining the elephant connection.

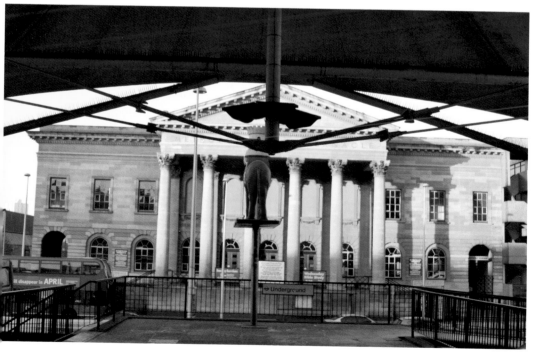

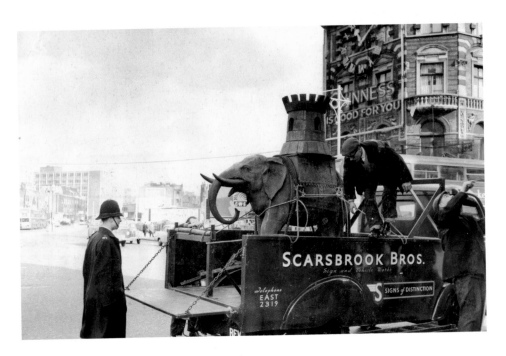

The Elephant and Castle Statue, *c.* 1950s/2012

An alternative explanation is the story that at least fifteen Lord Mayors of London were shareholders in the Royal Africa Company between 1660 and 1690, who made their fortune through the slave trade. The company's logo was an elephant with a castle, which became very popular as a name for pubs. A series of photographs by celebrated photographer Bert Hardy, were taken of the area for the magazine *Picture Post* in 1948. One photograph showing the statue was dubbed 'The emblem of the cockney world'. The statue also featured in the opening credits of the television series *Up the Elephant and Round the Castle* from the early 1980s, showing comedian Jim Davidson sitting astride it.

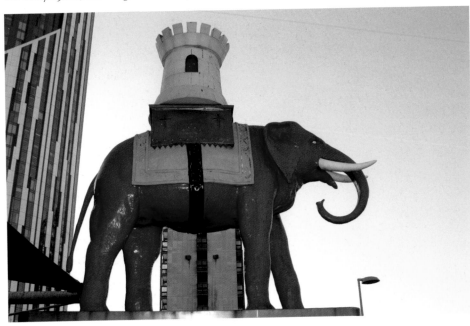

Elephant and Castle Urban Forest, Heygate Estate SE17, 2011/2012

All but a handful of residents have now been moved off this mammoth housing estate. Bulldozers are primed to move in to begin demolition, all part of a massive regeneration scheme. However, one of the few remaining people on site, Adrian Glasspool, began an urban gardening collective, which has at its heart the 450 London plane trees that make up this 'urban forest'. In celebration of the vast open spaces left behind walking tours were organised and vegetable plots created, tended to by locals, students and even an Indian takeaway restaurant. Well known 'guerilla gardener' Richard Reynold also joined the scheme. Despite initial opposition from Southwark Council there are hopes that a part of what they have created will be preserved in the final regeneration plans.

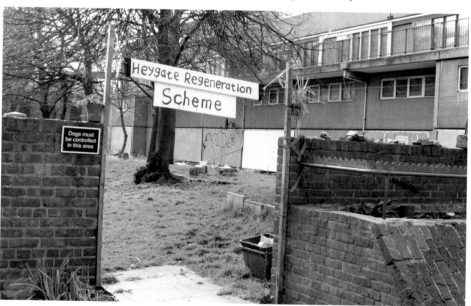

Welsh Presbyterian Church, Falmouth Road SE1, 1970s

Built in 1888, this former yellow and red brick Welsh Presbyterian chapel is a lovely building complete with stained glass windows. Listed by English Heritage, it is constructed in a mixed Romanesque revival and Queen Anne style. Formerly known as Calvinistic Methodists, the Presbyterian Church of Wales set up from the established church in 1811. The Brotherhood of The Cross and Star Pentecostal Church now occupy the building, and they have their headquarters in Nigeria. In the recent photograph the Shard, a 310-metre tall building by architect Renzo Piano, which is situated by London Bridge railway station, can be clearly seen in the background.

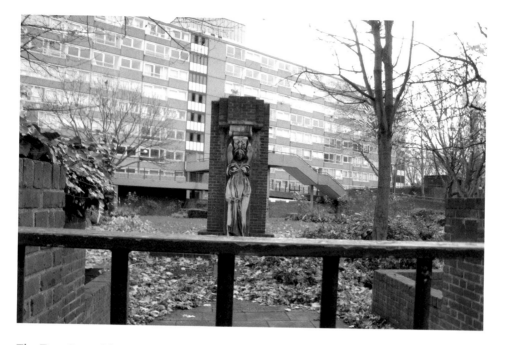

The Two Caryatids, Heygate Estate SE17 and Southwark Park SE16, 1980s

A caryatid is described as 'a sculptured female figure serving as an architectural support' and these fine examples were made by Henry Poole RA (1873–1928). Poole studied at the Lambeth School of Art and was master of the sculpture school at the Royal Academy from 1921 to 1927. They were originally designed as the old Rotherhithe Town Hall, which was converted to a library in 1905. It was severely damaged by bombing in the Second World War and later demolished. The caryatids moved to the Heygate Estate in 1974 and stood for many years in a garden there. One of them is detailed with oak, depicting strength and rebirth and the other with laurel, depicting peace and triumph. With the planned demolition of the estate as part of the overall regeneration of the area, a new home was found for them in the grounds of Southwark Park in SE16.

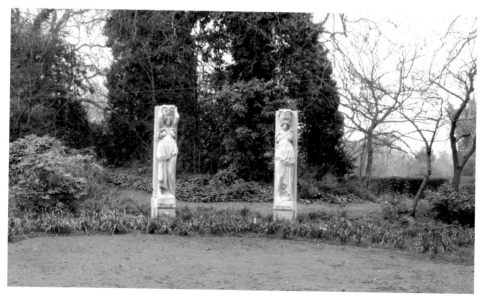

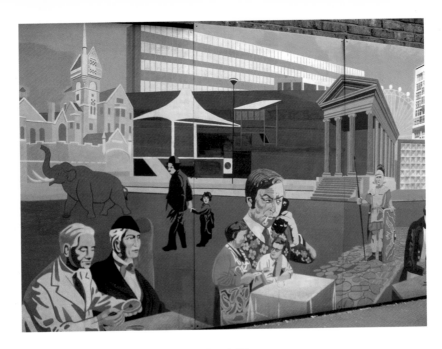

Crossways Church, 100 New Kent Road SE1, c. 2000

This church has been in the area since 1866, when the South London Mission began at the Elephant and Castle. The Crossway Central Mission church building was erected in 1905. The late 1960s saw the church, along with many local houses, demolished to make way for the enormous Heygate Estate. The new Crossway Church was incorporated as part of the estate in 1973. A walkway on its first floor led to an entrance to the church directly from the estate. Now part of the United Reformed Church and made up from many different congregations. As is reflected in the multi-cultural area in which it stands, the church is made of followers from all over the world, including West Africa, the West Indies, Eastern Europe and South America. At the street level, there were distinctive painted murals depicting buildings and characters of local interest, including the Tabernacle, the shopping centre, Charlie Chaplin and Michael Caine. In the run-up to the church closing due to the regeneration of the Heygate, these have disappeared recently, though the church is still open for business presently.

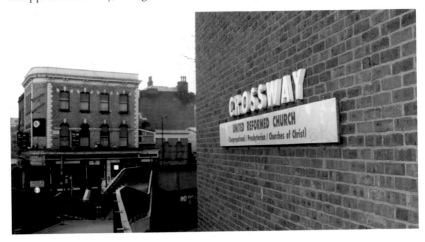

The Ministry of Sound, 103 Gaunt Street SE1, c. 1998

The world famous nightclub opened in September 1991 in an old bus depot in the back streets of the Elephant and Castle. DJ Justin Berkmann founded the club in partnership with Humphrey Waterhouse and James Palumbo, son of Lord Palumbo, former chairman of the Arts Council of Great Britain. Berkmann was inspired in his concept by the Paradise Garage club in New York. Over the past twenty years, every top DJ worth his salt has played here. Every Friday and Saturday night, long queues of club goers can be seen snaking their way around the neighboring local streets waiting to gain entry. On other nights of the week, the club is available for hire for private parties and events. The club has its own record label, radio station and a thriving online retail shop and mobile phone business. It celebrated its twentieth birthday in 2011. The ongoing regeneration of the Elephant and Castle area may place the immediate future of the club in some doubt however. With residential developments planned nearby, noise complaints are feared.

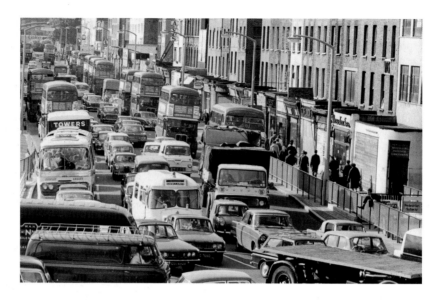

The Southbank University, London Road, *c.* 1970s

This is one of London's oldest and indeed largest universities, home to some 25,000 students from over 120 countries, and run by some 1,700 staff. It started life, funded by charitable donations, as the Borough Polytechnic Institute in 1892. Courses then included boot and shoe manufacturing, leather tanning, laundry and baking, trades long associated with the surrounding area. During the First World War gas masks and munitions were made here, and despite being bombed many times during the Second World War it provided hundreds of meals per day to the local homeless. Photograph shows the 1970s traffic flowing past what on the right is now the university. Over the years several local learning establishments joined forces with the BPI and it achieved university status in 1992, its centenary year, and became known as the 'University Without Ivory Towers'. The LSBU offers undergraduate and postgraduate degrees in Engineering, Sciences and Built Environments, Arts and Human Sciences and Health and Social Care. Celebrated alumni include artist Frank Auerbach, Norma Major, Olympic rower Greg Searle and architect David Adjaye.

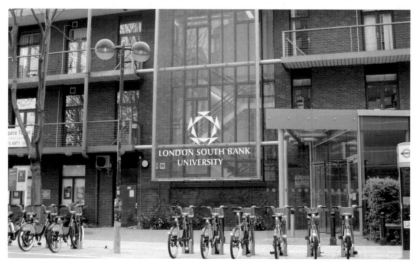

The Union Theatre, 204 Union Street SE1, c. 2002

Situated in railway arches near to Southwark tube station and the Tate Modern art gallery, this performance space holds approximately seventy people, but the company makes use of every spare inch in this one-time paper warehouse. Run by husband and wife team Sasha and Sean Regan, along with actor/director Ben De Wynter, the Union has gained a growing reputation for putting on top-quality musicals in particular. The 2009 all-male cast production of *Pirates of Penzance* won rave reviews and many awards. The show then transferred to the larger Wiltons Music Hall, E1, in 2010. Plans to tour *Pirates* in Australia in 2012 are well under way. The play *Irish Blood, English Heart*, written specifically for the theatre space by Darren Murphy and produced by Ian Groombridge, transferred in 2011 to The Trafalgar Studios on Whitehall. The Union also has a thriving all-day café out front, which both authors heartily recommend.

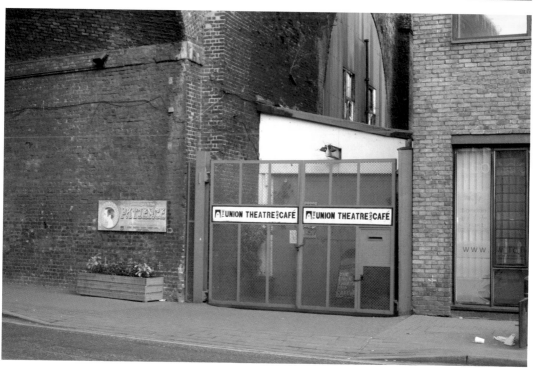

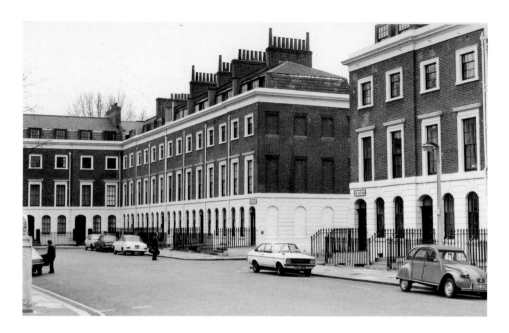

Trinity Church Square SE1, *c.* 1978

Close to the hustle and bustle of London Bridge station, this square has been described by first-time visitors as looking like something straight from a film set. The houses in this conservation area were built between 1824 and 1832 and most have now been converted into flats. What was the Holy Trinity church sits in the middle of the square. Now known as Henry Wood Hall, it has been a rehearsal and recording space since 1975 and can accommodate a full orchestra. Sir Henry Joseph Wood was a conductor well known for his work at the annual 'Prom' concerts. The gardens of the square are home to what is said to be the oldest statue in London. Thought to be of King Alfred, it once stood on the north front of Westminster Hall, which was erected in 1097. A residents association was formed in 1976 and this covers nearby Merrick Square and parts of surrounding streets in an area that has become known as Trinity Village.

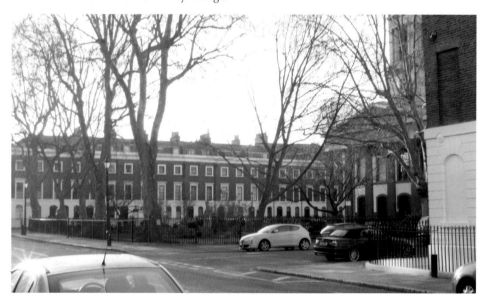

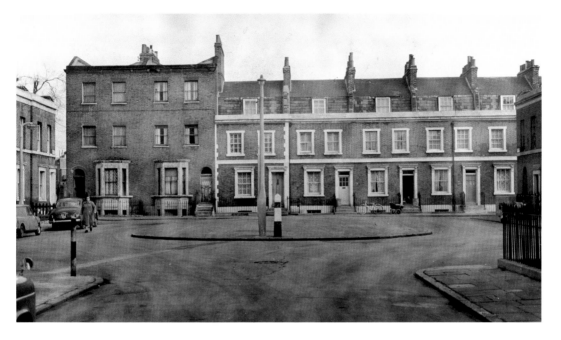

Baitul-Aziz Islamic Cultural Centre, 1 Dickens Square SE1, 1960s

Also known locally as the Harper Road Mosque, it has a capacity for around 2,500 worshippers. The history of this building can be traced from small gatherings in a shop basement. In 1990 a site was acquired in Dickens Square and from the original small *Masjid* (mosque/place of worship), which held just over 400 people, it grew into the grand cultural centre that is in place today. This opened in around 2008. Those that use the facilities today are mainly from the Bangladeshi community. Men and women from different ethnic backgrounds are welcome here and children attend Arabic and Bengali classes. Daily prayers are also taken.

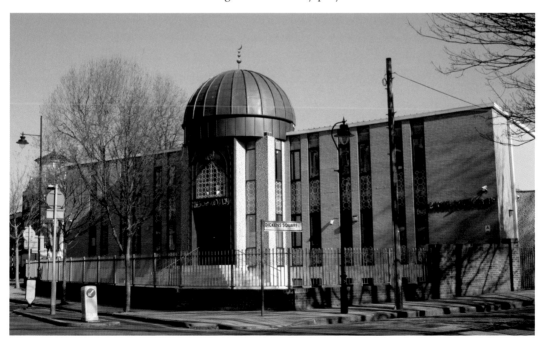

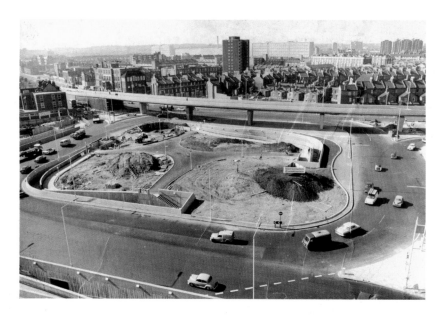

New Kent Road and Old Kent Road Flyover, _c_. 1969

As you travel down New Kent Road towards the start of the Old Kent Road, the large, grey concrete flyover looms into view. Opened in 1970, it was designed to help with the increase of traffic in the area. Originally it had two-way system, but due to the amount of accidents on the flyover it was reduced to its current one-way single lane. Travelling towards the A2 Old Kent Road from the Elephant and Castle, you veer left to take the junctions for Great Dover Street and Tower Bridge Road, but stay right and onto the flyover itself for the Old Kent Road. The Bricklayers Arms pub was to the left of the flyover. An inn was known to have stood there for over six hundred years, but this was a victim of the building work and new road layouts at the time of construction. Under the flyover there are public subways, and a large roundabout, which can be seen under construction in the photograph from 1969.

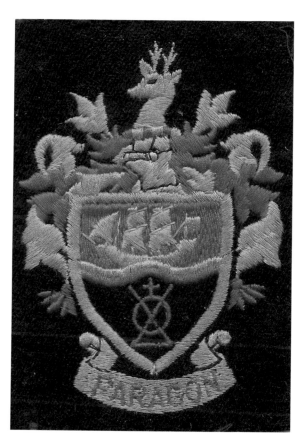

The Paragon School, Searles Road SE1, *c.* 1975

The name came from a crescent of houses called The Paragon. It was built here between 1787 and 1791 and designed by Michael Searles, surveyor for the Rolls Estate, who owned much of the land in this area at the time. The houses were demolished in 1898 to make way for a London School Board School. Though remembered as an all-boys school, girls and infants attended here before and after the Second World War, as can be seen by the carved signs above some of the entrances. A Second World War incendiary bomb landed in the playground during the autumn of 1943, failing to explode correctly. A major fire at the school in 1970 meant temporary portacabins were erected as classrooms due the damage, and these remained *in situ* for its remaining years. The tuck shop in the playground is a favourite memory of the pupils who attended the school during the 1970s. The school closed in 1981. Developer Sapcote Real Lofts converted the building into a gated luxury-housing complex, with million pound price tags being achieved on some of the apartments.

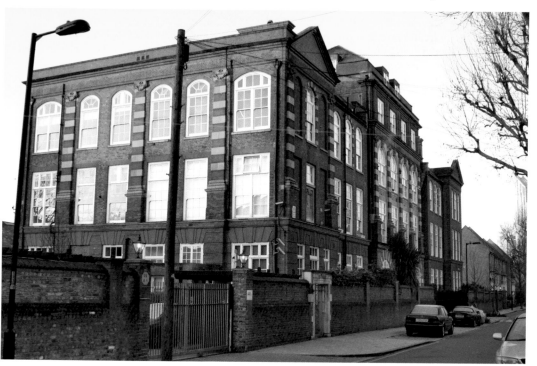

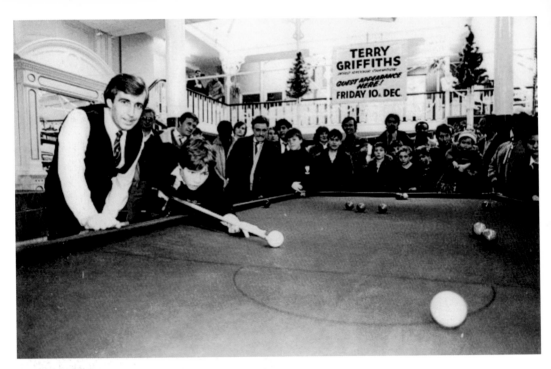

John Bennet and Co., 157/163 Old Kent Road, c. 1979

Founded in 1821 this company made billiard and snooker tables of a very high standard and were 'By Appointment to the Royal Family and War Office'. In 1899 they set up their headquarters in nearby Newington Causeway. In the 1920s they ran billiard halls in Hackney, Watford, and around Islington. During the Second World War, however they lost all of the halls, as well as their then shop, offices and factory, due to bombing raids. Settled on the Old Kent Road in the late 1960s, the shop had a full-size snooker table on show and visits from world champions of the game, such as Terry Griffiths, shown above. Snooker was very popular in the 1970s and 1980s in particular, riding a wave of record television audience figures. The shop also sold other sports equipment, with football kits available on the first floor, up the ornate stairway. Subbuteo pitches and teams were also on permanent display. The company was bought by E. J. Riley (Billiards) in 1980 and John Bennet's was no more. On the site now stands the Pay Less Express supermarket.

The World Turned Upside Down, 145 Old Kent Road SE1, c. 1970

Situated at the flyover end of the Old Kent Road, this strangely named pub is said to have been here since the 1680s. A couple of suggestions are made as to the origins of the name – the discovery of Australia in 1606, the ballad of the same name from 1646 or the one-time practice of pub sign writers depicting 'things the opposite of what is natural or usual'. The frontage changed a few times over the years and a part rebuild is noted for 1868, as well as in the 1930s. It was recognised as the 'home' pub of choice for the Pearly King and Queens of London. In recent years it was home to many DJ nights, including those run by Tony Class and many a pub singer has performed there, including the standard 'Knocked In The Old Kent Road' made famous by Albert Chevalier from 1939. The pub shut in 2009 and is now a Domino's Pizza Parlour, with eight luxury apartments above it.

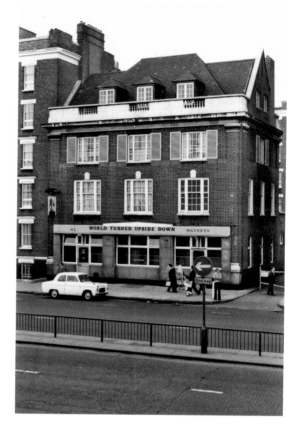

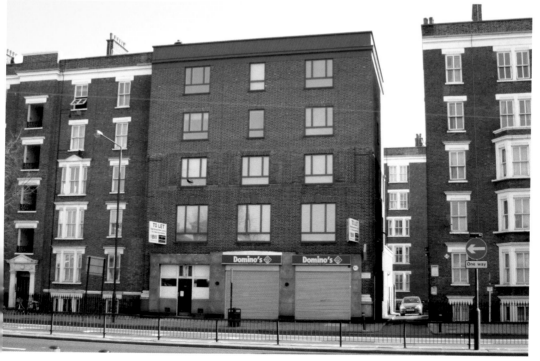

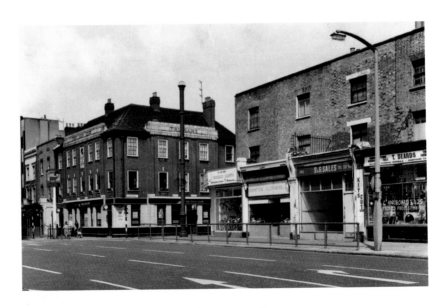

The Dun Cow, 279 Old Kent Road SE1, c. 1978

The nightlife of The Old Kent Road – incidentally the cheapest property on the Monopoly board and the only representative from South London – and especially the pubs that stood upon it, were a means to an escape from the everyday life, especially at the weekends. Thirty-nine pubs once stood on this historic Roman highway. The Dun Cow – whose name was either inspired by Lindisfarne monks founding the city of Durham at 'Dun Holm' in 995AD, or the mad cow of Dunsmore, Rugby, depending on whom you talk to – was a very popular boozer that opened in 1856. It was known as a famous Victorian 'Gin Palace', boasting eleven drinking rooms. It went all 'cocktails and champagne bar' in the late 1970s until the mid 1980s, with many well-known DJs working here including Steve Walsh, Greg Edwards and Robbie Vincent. It closed in 2004 and is now a GP surgery, though the pub sign featuring the cow still hangs out front and the name of the pub is still clearly visible as you travel towards it.

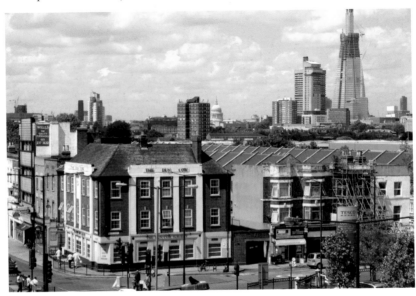

The Thomas à Becket Pub, 320 Old Kent Road, *c.* **1970 and 2008**

A famous old pub situated on the corner of Albany Road and Old Kent Road, the 'Becket' has a rich and varied past. It is named after the one-time Archbishop of Canterbury, Thomas à Becket (1118–1170) who was declared a martyr and a saint following his assassination by followers of Henry II in a dispute over church privileges and rights. The spot where the pub stands, on the old coaching road to Kent – hence the name of the road, was once St Thomas à Waterings. It was used not only known as a resting place for those on a pilgrimage to Canterbury, but also a well-known location for executions. In the more recent past it has been known as a boxing pub, complete with legendary gym. Top-class talent has trained here, including the well-loved British and European heavyweight champion Henry Cooper, who used it as his base from 1954 to 1968.

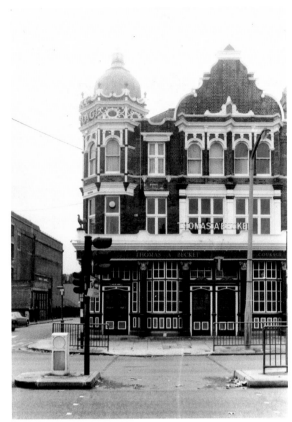

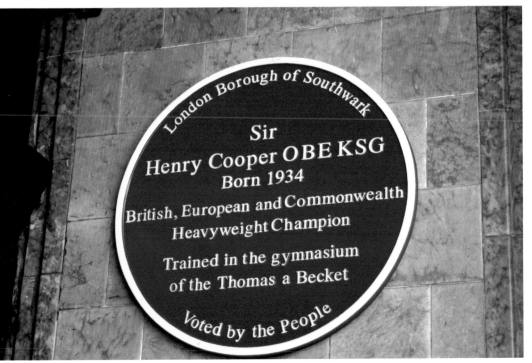

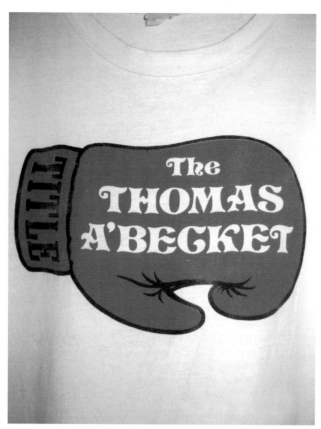

The Thomas à Becket, 1980s and 2012

Other stellar names that sparred here include welterweight Sugar Ray Leonard, heavyweight Joe Frazier and perhaps the biggest name of all, Muhammad Ali. Singer David Bowie rehearsed here during his Ziggy Stardust days and actor James Fox trained in the gym in 1968, for his part as Chas in the film *Performance*. One-time boxer and promoter Gary Davidson turned the bar into a boxing museum in the mid-1980s. Sir Henry Cooper (1934–2011) came back to the pub in September 2008 to unveil a plaque to mark the location of the famous gym. The pub, which has a distinctive white stone dome, has closed a couple of times in recent years, only to then receive a new lease of life, and it is currently a bar, restaurant and club.

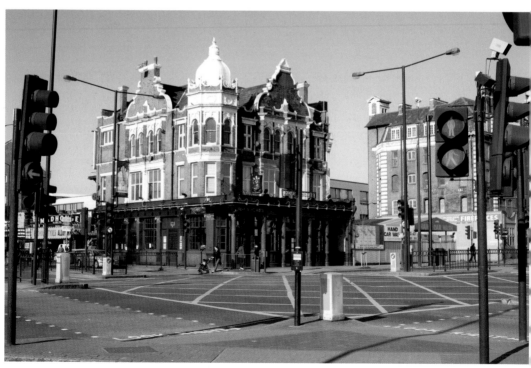

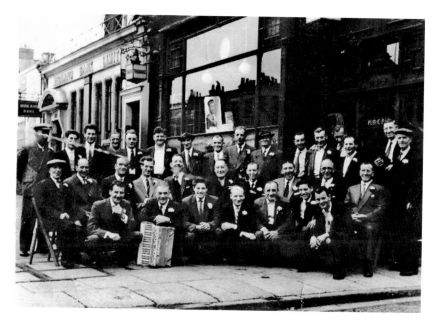

The Green Man, 278–280 Old Kent Road, 1950s

In the photograph above, a group of revellers gather, complete with accordionist, outside The Green Man pub on the Old Kent Road in the mid-1950s. A Green Man Inn has stood here since around 1808. A tollgate was once located outside the pub, operated by the Turnpike Trust to fund road improvements. The pub was rebuilt in 1880 and its interior had some very distinctive tiles depicting Robin Hood, Friar Tuck and other Merry Men. By the early 1980s, this was a very popular pub on the Old Kent Road circuit, along with The Frog and Nightgown, The Dun Cow and the Gin Palace. It closed a few years back, becoming a Chinese restaurant called Yummy Yummy for a while and is now the Steak House restaurant; today the tiles can still be seen in all their magnificence, after a few years of being covered up.

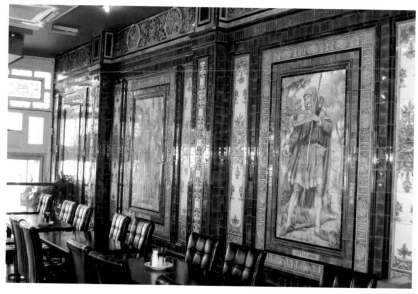

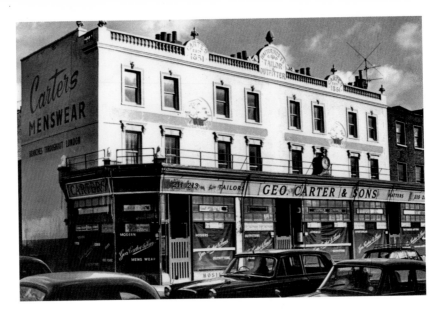

George Carter & Sons Ltd, 211–217 Old Kent Road, 1970s

This business began in 1851. From very humble beginnings it grew into a very impressive drapers and menswear clothing emporium. At first George, a hatmaker by trade, displayed his wares in a glass case in his front garden. Demand for his work was such that a shop was opened. The interior of which is described as being 'all highly polished wooden and glass cabinets and counters'. Money from customers was put in metal tubes and transported by pulleys and levers around the shop until it finally landed with a head cashier. Carter had novel marketing ideas. He had coins minted with his likeness on one side and his trademark on the other. These he then threw off the top of trams and later from his chauffeur-driven car. The business had up to thirty shops, a warehouse and factory at its height. The clock above George Carter & Sons had a bowler-hatted head on top of it. Upon striking the hour, the hat would rise up! The shop closed in 1978, later becoming a tyre shop. The building collapsed and the clock was seemingly lost. The site is now a British Heart Foundation Shop.

Millwall Football Club, Zampa Road SE16, 1970s and 1992

Millwall FC is the biggest football club local to Walworth and has many supporters who live in the area or once did, many of whom return on match days. Workers at J. T. Morton's canning factory on the Isle of Dogs, which had many workers from Dundee, Scotland, founded the club in 1885, hence the team's blue and white kit. It moved to South London in 1910, setting up home at The Den in New Cross. Notable events in the club's history include the 1945 Southern FA Cup Final versus Chelsea at Wembley and establishing a record of fifty-nine unbeaten home games from August 1964 to January 1967. The club finally achieved promotion to the top division of the English league in 1988/89, managed by John Docherty, even topping the table in that October after a great start to the campaign, before finishing a creditable tenth. However, relegation followed at the end of the 1990 season. The club moved grounds in 1993, and was now playing at the all-seated stadium known as The New Den, a short walk from the old ground. The then Labour party leader John Smith conducted the opening ceremony.

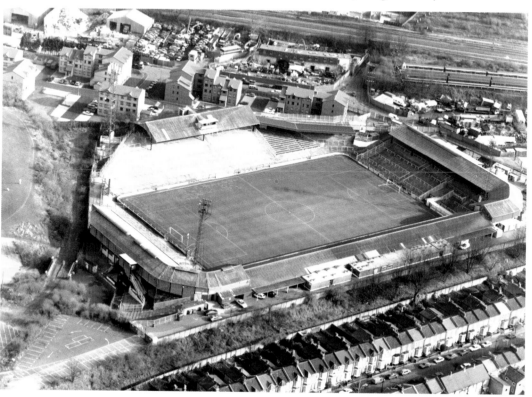

MILLWALL
FOOTBALL
CLUB

official
programme
one shilling
(Incorporating Football League Review*)*

FOOTBALL LEAGUE DIVISION TWO
FRIDAY 26th DECEMBER 1969 KICK OFF 3 p.m.

QUEENS PARK RANGERS

**Millwall Football Club, Zampa Road SE16,
c. 1969 and 2012**

The club nearly folded in 1997 suffering severe
financial problems. Theo Paphitis, now of
Dragons' Den television fame, stepped in and
became chairman. The club recovered and
in recent years have visited Wembley for a
Football League Trophy final versus Wigan
in 1999, Cardiff for the FA Cup Final versus
Manchester United in 2004 and played in the
UEFA Cup competition in 2005. American
millionaire John Berylson bought the club in
2007, installing Kenny Jackett as manager and
decent success has followed. A Wembley play-
off defeat to Scunthorpe in 2009 was followed
by a win finally at Wembley over Swindon in
2010, ensuring promotion to the Championship
division. A section of the club's supporters have
had a notorious reputation over the years and
their motto of 'No One Likes Us, We Don't Care'
is known the world over. Favourite players
of the authors include Alex Stepney, Barry
Kitchener, (1947–2012), Harry Cripps (1941–95),
Bryan King, Derek Possee, Alf Wood, Gordon
'Merlin' Hill, Terry Hurlock, Keith 'Rhino'
Stevens, Teddy Sheringham, Dennis Wise,
Timmy Cahill and Neil Harris.

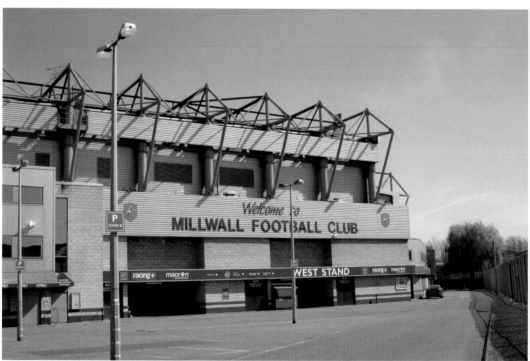

Bert's Pie and Mash Shop, 184 Old Kent Road and 3 Peckham Park Road, 1970s

Nothing divides South Londoners more than when the discussion gets around to their favourite pie and mash shop. For the Walworth contingent, Arment's is best, no argument. The Bermondseyites often plump for Manzes' or Joyce's. One other favourite was Bert's, of which there were two shops: one in Old Kent Road, now a doctors' surgery, and the other in Peckham Park Road, which closed in 2008 after more than seventy years of trading. On its last day, the authors managed to secure two plastic hand-painted signs from the shop window, one stating 'Hot Eels' and the other 'Meat Pies', shown right. The shop is now Angelo Flooring.

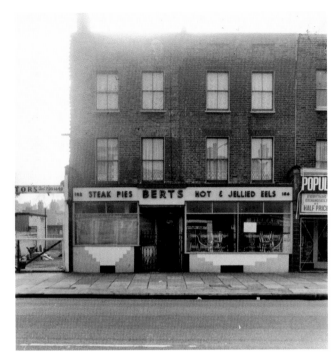

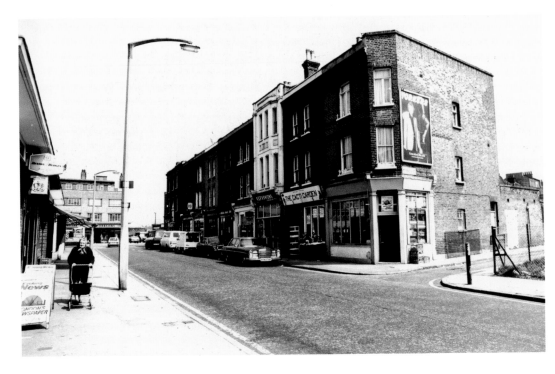

Rajah Tandoori and Curry, 342 East Street, 1970s

A much loved local Indian restaurant, often referred to as the 'best curry house in South East London'. Established in 1981, this family-run business has won many awards for its cuisine. The first ever Indian restaurant in the UK opened in 1810, in George Street, Westminster. Called the Hindostane Coffee House, it was owned by Sake Dean Mahomed (1759–1851). The Rajah has an extensive menu and also offers free local delivery.

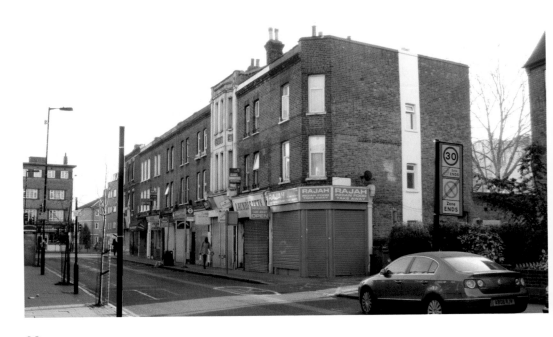

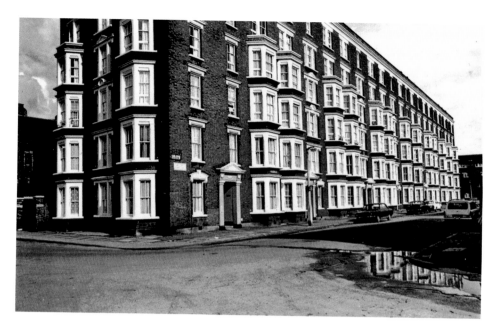

Darwin Court, 1 Crail Row, 1960s

Run by Peabody Trust, Darwin Court opened in 2003. It was designed by architects Jestico and Whiles and built by Walter Llewellyn & Sons, and provides seventy-six one- and two-bedroom flats for residents aged fifty and over. It actively promotes independent living. The flats are built on five levels and were designed to the 'Lifetime Homes' standard, making them adaptable for those with disabilities. The complex has its own on-site restaurant, community centre, well-tended gardens and a swimming pool, which is also open to non-residents at certain times during the week. Regular keep-fit, yoga and line-dancing classes are held and a hairdresser visits on a regular basis. Former Prime Minister Gordon Brown once described Darwin Court as 'pioneering' at an Ageing Population Housing Strategy launch event.

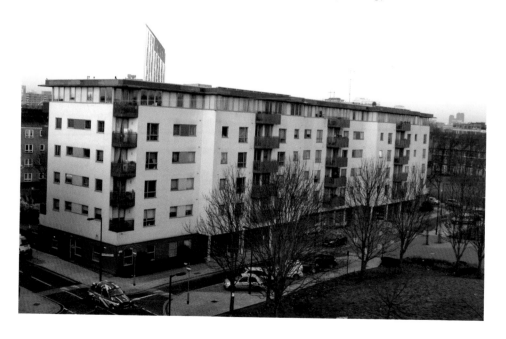

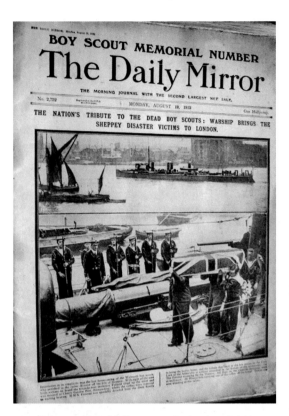

The 2nd Walworth Scout Troop, Larcom Street SE17, c. 1912 and 2011

Based at St John's church, Larcom Street, the troop had set off for Leysdown, the Isle of Sheppey from Erith, Kent, on 4 August 1912 aboard an ex-naval cutter. Twenty-three sea scouts, the scoutmaster and five helpers made up the crew. Due to a huge sea squall, the boat capsized. It managed to right itself only to capsize again causing all aboard to end up in the water. The Leysdown coastguard launched and rescued fifteen of the scouts and five adults. However nine boys in total lost their lives, eight of them from Walworth. Among them was patrol leader William Beckham aged twelve. His two brothers, also in the boat, survived. All three were ascendants of footballer David Beckham, one of them his great grandfather. The bodies were transported back to London on the destroyer *Fervent*, deployed by Winston Churchill, then First Lord of The Admiralty. This national tragedy made the front pages of all the newspapers at the time. Over a million people lined the route of the funeral procession from St John's to nearby Nunhead cemetery.

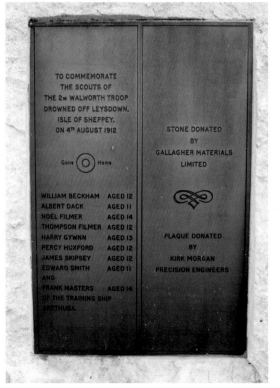

The Beaten Path, 267 Walworth Road, c. 1978

Situated to the north side of the entrance to East Street market, this was a big mid-Victorian pub, known for selling real ale. Popular with the Irish community, there were many pieces of memorabilia from Ireland dotted around the bar. Willy was the well-known landlord. Once known as the Prince Alfred, it gained its last name in around 2005. After the retirement of the freeholders, it closed in 2011 and is now a greengrocer and butcher's called 'Buy n Buy'; yet another pub gone from the Walworth Road.

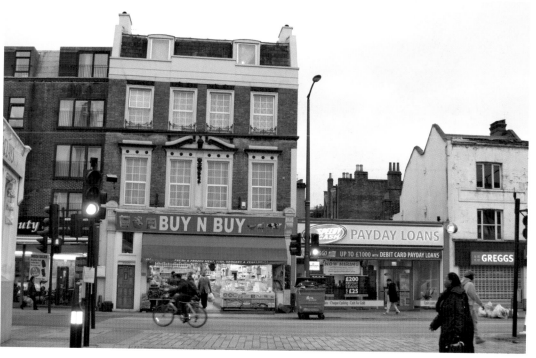

The Robert Browning Amateur Boxing Club, Walworth Lower School SE17, 1960s and 2011

There is a long history of amateur boxing in the South London area. One of the most popular clubs was the Robert Browning Boxing Club, named after the English poet (1812–1889), which was operated out of this school. Many local youths trained here and boxed under its colours, picking up multiple awards between them. In the late 1950s, the Kray Twins – Reggie and Ronnie – trained here three nights a week. Each showed promise and by the age of fifteen, in 1958, Ron was Hackney Schools champion, with Reg a Great Britain schoolboy champion. John H. Stracey boxed here in 1966, the year he won the junior ABA title (fourth right, back row). He then moved to The Repton Club, to avoid Terry Waller in the South East Divisionals, before fighting him in the London finals. In 1975 Stracey became world welterweight champion, defeating Jose Napales in Mexico City.

Threadneedleman Bespoke Tailors, 187A Walworth Road, c. 1974

Once a regular site on the streets on the UK, many bespoke tailors have not had a happy time of it in recent years. With many high street retailers now offering ready-made suits for sale at very reasonable prices, the demand for a fully handmade suit has fallen. Tailors have been on these premises for over eighty years, however. The name of Ron Martin was above the shop for many years, and for the past sixteen years, it has been the shop and workroom of George Dyer, trading as Threadneedleman Tailors. George's father, Oscar, was a trousermaker who plied his trade on his arrival from Jamaica in the early 1950s. He passed on his love of clothes to his son, who also learnt a lot from the likes of Bert Towsey, seen in the photograph above. In recent years George has made suits for well-known personalities such as Suggs of the pop group Madness and former world heavyweight boxing champion David Haye.

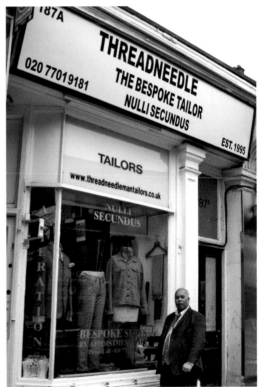

Walworth Surplus Store, 211 Walworth Road, c. 1968

This is a real curiosity shop. The owner Les is a real old character to say the least. Mr Cohen, his father, opened the shop in the 1930s and he also a similar store called Winners further down Walworth Road, which closed in the 1980s. Les, who has worked here since just after the Second World War, arrives each day and spends hours hanging up the khaki trousers, high visibility vests, camping equipment, work boots and army-style coats outside the shop, and then an hour or two later starts to take it all down again. The interior of the shop appears to be a real jumble, but Les knows where everything is. There are some gems to be found in there, but timewasters beware: if you venture in, buy something!

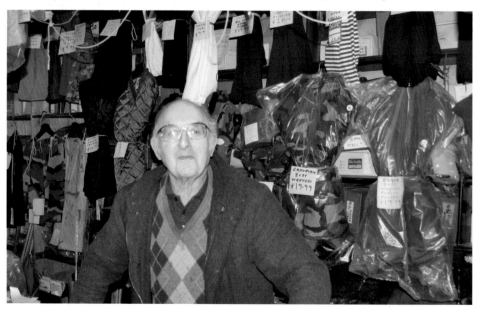

Wimpy Bar – 235/347 Walworth Road, c. 2007

We have the Popeye cartoons of Elzie C. Segar to thank for the name of this, the UK's first homegrown fast-food outlet. The character of J. Wellington Wimpy gave his name to this brand, created in the 1930s. Twelve restaurants bearing the name were in operation by the start of the 1950s, owned by American Eddie Gold. The first actual Wimpy Bar opened within the Lyons Corner House in Coventry Street, London, in 1954, with J. Lyons & Co., famous for its teashops, having licensed the name. Cue the arrival of toasted buns, Brown Derby, the Bender and French fries! There were two Wimpy Bars in the Walworth Road. No. 347, on the corner of Liverpool Grove, was later a branch of Starburger and is now the African restaurant Moyoma. The Wimpy at no. 235, which opened in the mid-1960s, traded up until late 2008 and is now the restaurant Mama Thai.

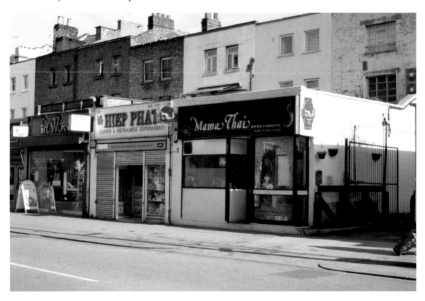

Acknowledgements

Darren dedicates his work on this book to his dad Billy Lock, who also shared the love of Walworth. Also to Diane, Kevin and Mick, and my better half Lisa. It is also for Johnny and Lesley Scanlon, Pat Davis, Jacko McInroy, Paul Prior, Stephanie Fraser, Diane Charlesworth, Sam Mullins and the Lynn Boxers, Sid Charlesworth and Sid Charlesworth Jnr, George and Tony Mothersole, and the Roffo Family.

Mark dedicates his work on this book to John and Bet Nicholson.

Many thanks to the following (in no particular order): Patricia and staff at John Harvard Library; Sarah and all at Amberley; George Dyer, Fred and Kay Harris, Richard and Bill, Jean Baxter, Carol, Clark, Gary and all at Edwardes; Natty Bo; Andrew Moughtin-Mumby; Dave; Graham and staff at T. D. Sports; Mark O'Shea; Charlotte Benstead and staff at Creation; Helen; H at Mary's; Brenda at Whitehall Clothiers, Louise; Bet; Jan; Janet and Robin Davies of the Kennington contingent; Sasha and Sean Regan; Ron and Paul at Rose Bros; Sharon Purcell; Lucy Pepper and the Millwall Museum; Dean Powell; Gary Davidson; Roy Edwards and Les.